Early Dylan

Photographs by Barry Feinstein, Daniel Kramer, and Jim Marshall
Foreword by Arlo Guthrie

A Bulfinch Press Book
Little, Brown and Company
Boston • New York • London

First Edition

ISBN 0-8212-2534-0

Library of Congress Catalog Card Number 99-72456

Bulfinch Press is an imprint and trademark of Little, Brown and Company (Inc.)

Printed and bound by Amilcare Pizzi, Milan, Italy

Gallery representation for *Early Dylan:* Fahey/Klein Gallery, Los Angeles

PRINTED IN ITALY

I dedicate this book to Alfred and Susan Schweitzman, my son and daughter Alex and Alicia, and Judith Jamison. — Barry Feinstein

For Arline, Bob, and all those who are forever young. — Daniel Kramer

Although this book is about Bob Dylan, I would like to dedicate it to and thank all the other singer-songwriters from then and now. To Phil Ochs, John Prine, and Sonia Rutstein — and all of those whose work we have not heard yet. — Jim Marshall

Acknowledgments

I would like to acknowledge the following people: Rose Feinstein, Erika Marshall, Pete Mauney, Jim Marshall, Karen Dane, Michael McLean, Dennis Hopper, David Fahey, Roger Vaughan, Tad Wise, Jeff Rosen, Bob Dylan, Kerry Shear, and Wilford Brimley.
— *Barry Feinstein*

Although there are many people to thank for their encouragement and help with the making of my pictures over the years, some who effected the outcome of this book are Bob Dylan, Jeff Rosen, our dauntless editor Karen Dane, David Fahey, Philip Cowan, Harold Leventhal, my family — the memory of Philippe Halsman and W. Eugene Smith — and, of course, my one and only, Arline Cunningham Kramer.
— *Daniel Kramer*

I'd like to acknowledge the artists, managers, and concert promoters who gave us their trust and the access. I'd also like to thank Bert Block, who gave me my first break in 1962; David Gahr, who is more than just a good photographer but also a very close friend; George Wein of the Newport Folk Festivals; and Marshall Lumsden, a photography editor for the *Saturday Evening Post* who gave me a Dylan assignment in 1963 that led to the (now famous) tire shot. There is also my agent and friend, David Fahey — without him, my first book and this one would not exist. Last but not least my editor, Karen Dane, who has put up with my tantrums — and I'm sorry for any gray hair I may have caused her.
—*Jim Marshall*

Foreword
Arlo Guthrie

I was thirteen years old when, in early 1961, Bob Dylan first came to our house. He knocked on the door and I opened it. A nervous young man, maybe in his early twenties, he asked if this was where Woody Guthrie lived. I invited him in. We played harmonicas together for a little while. He went off to see my dad later that day or pretty soon thereafter. There had been others before him asking about my father, but this one was different; well, he seemed different anyway. That was a long time ago. He was different all right.

Over the next few years, in the early sixties, everyone in my world was singing Bob Dylan songs. It was as if we were in some worldwide musical stage show and Bob Dylan was writing the lyrics for the entire production. He was writing about freedom, wars, disasters, justice, betrayal, liberty, slavery, outlaws, freight trains, and women; all the usual stuff. And at some point he stopped being a folksinger and a songwriter and he became a warrior poet. For the first time in my life I saw a pen that put swords to shame.

And he was singing. It wasn't the kind of singing people were used to either. He taunted, sneered, whispered, and snarled at friends and enemies alike. He seemed to be pushing himself to see how far he could go and what he could get away with, and to everyone's surprise, including his, he kept going and going and getting bigger and more important.

It was a great time for truthful words. It was a good time to be Bob.

And the truth was that he was just doing his own thing. He was fighting his own fights, saving his own world, healing his own wounds, and singing his own songs. Bob Dylan was walking his own road, on a highway that belonged to everyone.

And the faces of the moments from those years have been captured by some of our best photographers and put into this book. These aren't just pictures. They are moments etched in the memories of an entire generation. They are the moments when we found our own voices in the faces of our heroes and within our own hearts.

May it always be a good time to be Bob.

Introduction
Barry Feinstein

My friendship with Bob began in September of 1963. As a favor to my old friend Albert Grossman, I agreed to drive his 1953 Silver Dawn Rolls-Royce from a Denver dealership, where it had been repaired, to New York. "Too bad I don't have someone to drive with," I said. Albert mused, "Maybe Bob would like to take a ride with you." At this suggestion, Albert's client, the young Bob Dylan, smiled.

We flew out of La Guardia the next afternoon, landed in Denver, and checked into the Hilton Hotel. That night we went to a coffeehouse, where people began noticing Bob. That really amused him. His second record, *The Freewheelin' Bob Dylan,* had just been released.

The next morning I went to get the car and picked Bob up at the hotel. As I pulled into the semicircular entrance I could see him standing there in the lobby, like a waif. He started toward me smiling, and the whole lobby froze. Then he got in and we Rolls'd away.

Down the road, Bob said, "Barry, I was thinkin', I'd like to see a place I worked at in Central City. Okay with you?"

"Okay with me. Central City it is."

Forty-five minutes later we pulled up outside an old-style saloon.

"I played piano for a stripper in there."

"You want to go in?"

"Nah, they fired me. I just wanted to see it."

We doubled back to Denver, and then went north to Cheyenne, Wyoming, where we stopped at a western clothing store for some shirts, pants, and a vest for me. Then we picked up Route I-80 East and drove across Wyoming into Nebraska. On the way into North Platte, Nebraska, we saw this big sign for a "Revival Meeting." We parked, got out of the car, and walked over to the entrance, which read, "Open one at a time!" Once inside the first door, we found ourselves in a pressurized chamber in an inflatable tent. We closed the outside door, opened the inside one, and stepped into a gale-force revival meeting: organ, drums, bass, and choir, with singing and preaching side-by-side.

We sat down and were revivalized. I was starting to mumble along with the "be praise-suhh-dah!" stuff when Bob and I exchanged a look. Then, moving with the music and the words of the Lord, we made for the door. I told Bob to stay with me but he was moving with the Lord. I stepped through the first door into the chamber and then opened the next door before Bob had closed the first door. Then there came a great wind. We had failed to keep the commandment above the door, and the tent lost a lot of air.

We walked fast to the Rolls giggling, trying not to stare at the dented tent behind us, when one of the preachers came out to see who'd let God's wind escape. He followed us to the middle of the parking lot, and watched us step into the silver car and roll away.

That night we raced a freight train across the Nebraska plains for as long as the road and tracks ran together, which was nearly two hours at seventy miles per hour. There was a three-quarters-full yellow moon in the sky up ahead, and in the headlights the corn looked as if it was made of aluminum foil. Sometimes we'd pull ahead and then the train

would lead. When we were neck and neck, we'd honk at each other. The train's horn was louder than ours was, but our horn was higher. When we honked together, it was as if we had the same ideas about cars and trains, maybe life and death. An hour went by like a minute and my cheeks ached from smiling so hard. Eventually the train veered northeast and we honked out two short blasts and a long one in farewell. The engineer echoed our phrase but more slowly, and then we were on our way.

We ate dinner at a truck stop and checked into a motel. The next morning we stepped outside and found a bunch of pickup trucks parked all around the Rolls. What a picture.

"Mornin'," I said.

"Good day for a drive. That your car?"

"No, it's a friend's. We're driving it east."

"…to save it from sandstorms," Bob added. "The paint doesn't do well in sandstorms."

"No desert around here."

"I hear it's moving north through Mexico," Bob said.

"You don't say.…Well one thing's for sure. Ain't never seen a car like that."

"That's what everyone says."

We continued on I-80 across the plains into Illinois. "Masters of War" and "Don't Think Twice" came over weak radio signals from college stations. We pulled over once to listen. Bob and I never did too much talking anyway. It was one reason we got along.

In Chicago we took a day off, and each of us went our own way. Then we hooked up again on the North Side and got back onto I-80 all the way to I-76. We drove to Amish country, the Rolls weaving through horse-drawn buggies. In Lancaster, Ohio, we came upon five or six buggies, all tied up in back of a low building. We parked and went in the back door and found ourselves in a poolroom with all these Amish kids who were smoking cigarettes, drinking beer, and shooting pool. I wish I had a camera that time, too.

But there's a time not to take pictures. And that's really all I want to say here in this introduction. It's what I've always said to anyone asking about how I got an image of Dylan or anyone else. Before I picked up the camera, I became Bob's friend, and the images reflect our friendship. The real answer to the question "How did you take that picture?" becomes "By not taking it at least not for a while."

I don't know about Dylan's getting high, or what ladies came and went, or which religions, or whether he was playing acoustic or electric; all I know is that I liked him and I still do. To me, these pictures show him at his most interesting, his best — and that's all I was looking for. Dylan is the only person that I know who has done contemporary musical literature. The only Bob was Bob, and these are my pictures of him.

Introduction
Daniel Kramer

The first time I saw Bob Dylan he was performing on a TV show. I knew nothing about him, but it was easy to see from this one appearance that he was indeed a special talent. Moved and intrigued by his performance, I found myself wanting to photograph him, but I had to run the gauntlet of Dylan's office and managers for over a full year before a picture session would be arranged. On a warm August day in 1964 when I arrived at the Woodstock home of Dylan's manager, Albert Grossman, little did I realize that it would be just the first of many times I would photograph Bob and that the pictures would have a life of more than three decades and counting.

After Bob saw the pictures of our first day's shoot, he invited me to photograph on many more occasions. As I worked making these pictures, I got closer to the person behind the celebrity — photographing him with friends, at concerts, backstage, at recording sessions, at parties, and during our making of album covers — and I experienced the pleasure of getting close to his work and music, sometimes without the camera. I came to realize I was documenting a special time and talent and, to this day, count these experiences among the most exciting and interesting of my photographic life.

During this period in the '60s, when Dylan electrified his music and surrounded himself with a band, he was going to the next plateau, effectively changing what was happening in music. These were heady days, and many of us went along for the ride — with Bob out in the first car of the roller coaster.

Whether by happenstance or by design, it is difficult to know Bob Dylan. We see him, we hear him, we know the facts of his beginnings and early performances, and we certainly know what he's done lately. There are endless books and articles speculating about who Dylan really is, yet it's hard for me not to think of him as anything but enigmatic, as constantly changing as a kaleidoscope, dancing "beneath the diamond sky with one hand waving free."

Early on as a photographer I realized the power of the camera as a tool. With it I could share with others my vision and thinking. I could point out what I wanted them to see or understand. This is a responsibility that constantly challenges the photographer. At its best, a photograph becomes a window through which not only the photographer can observe and preserve, but it also becomes (sometimes) the only window through which the viewer can see or "be there" and witness rare moments in time.

I hope that these pictures are a window, albeit a small one, through which you can glimpse a bit of Bob Dylan you may not have seen or felt before and that the curtain, for a fleeting moment, is moved aside.

Introduction
Jim Marshall

My coauthors, Barry Feinstein and Daniel Kramer, had a much closer relationship with Bob Dylan than I ever had. They went on tour with him and had far greater access, something that very rarely happens today. I cannot say that I even knew Bobby well, not like Barry and Dan and my friend David Gahr, who I wish had joined us in this book. But for me — and this is important — the world really needed to see Barry's photos of Bobby and so many of Dan's that have not been seen.

I am not really qualified or articulate enough to say how influential Bob's work is, but I know his songs will live forever. And the songwriters who followed in his footsteps are so important; for me, the most noteworthy is Bruce Springsteen and a young songwriter named Sonia Rutstein from Baltimore.

When I think back to those early days, I'll always remember one thing about Bob Dylan: the respect he showed not only for his music and that of others, but his reverence for the older musicians who came before, especially Pete Seeger and Johnny Cash.

Barry and Dan's photographs are those of an insider working with Bobby; mine are those of a kind of outsider looking in. I'm reminded of so many feelings — most of them good — when I hear those songs or see these pictures. It's the one place where no one gets old, where we can be forever young.

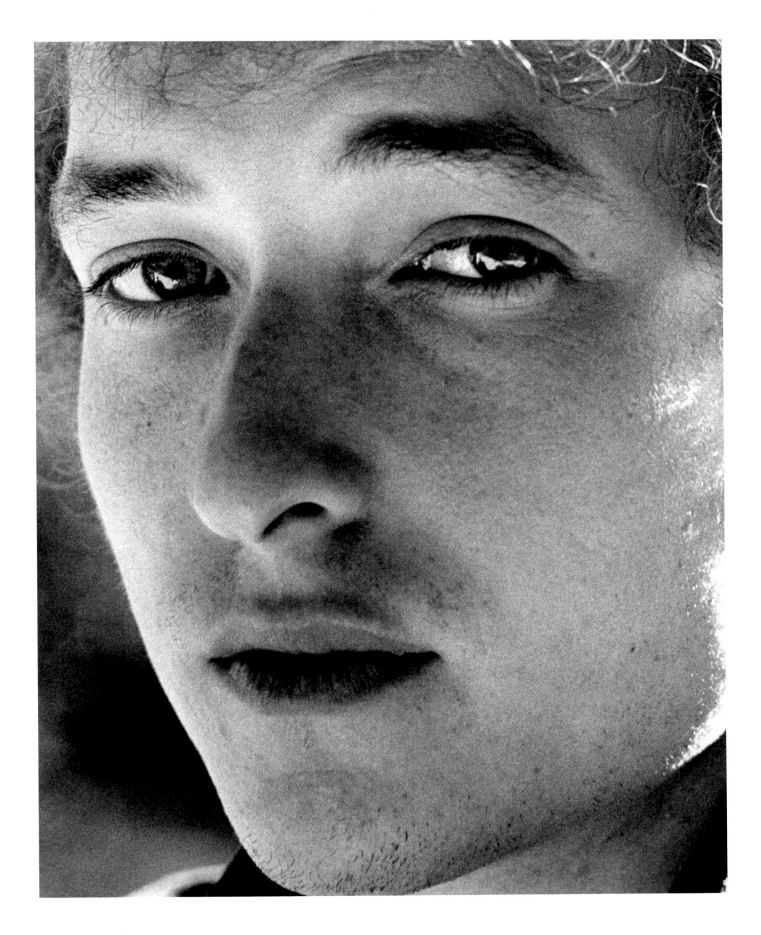

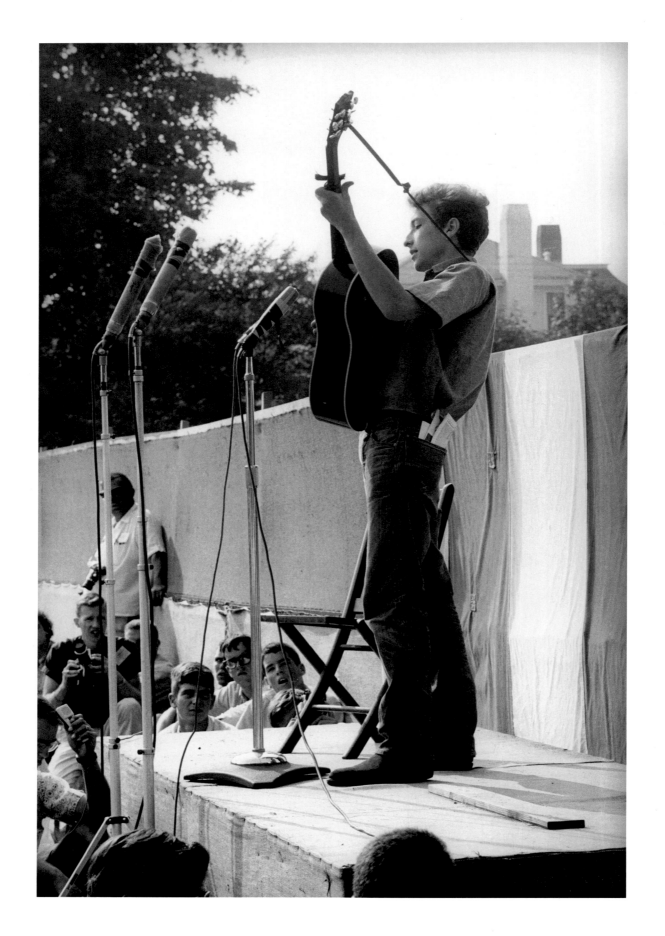

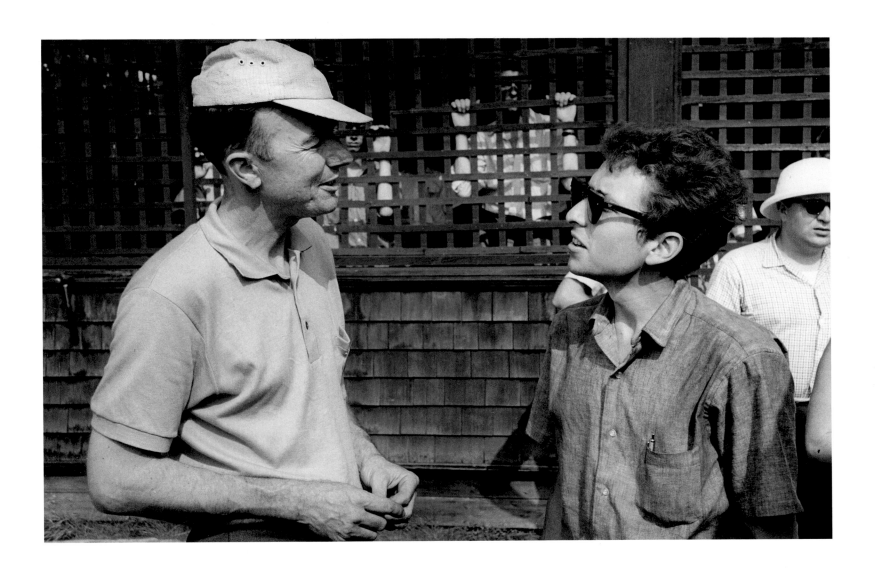

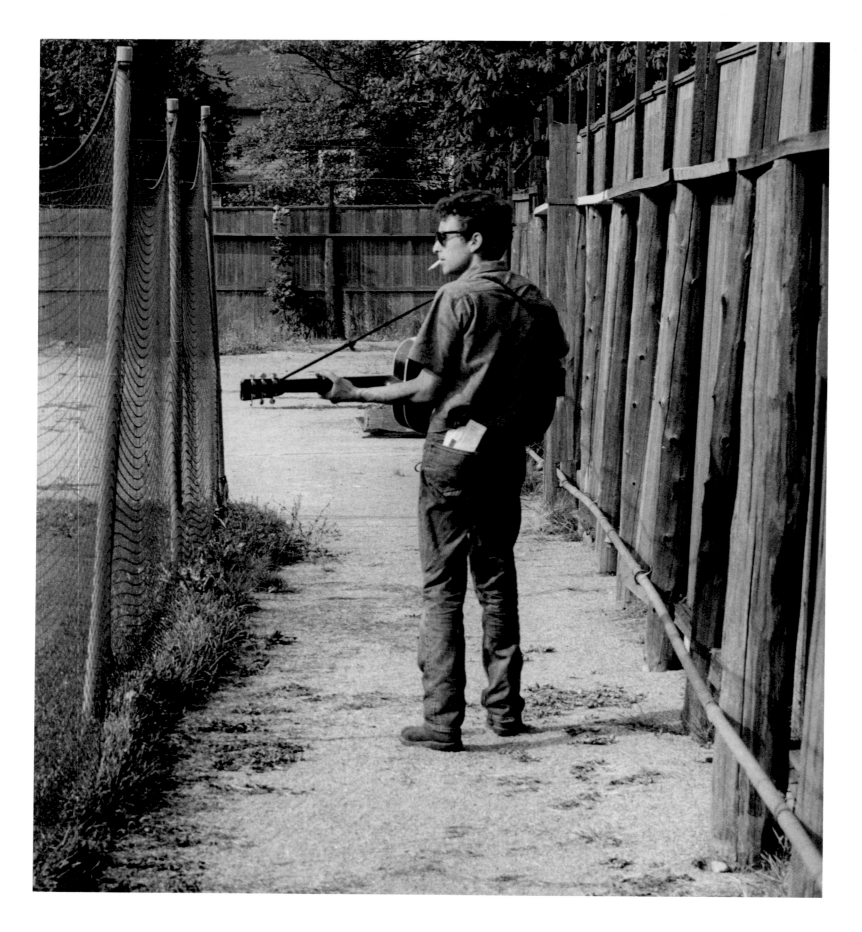

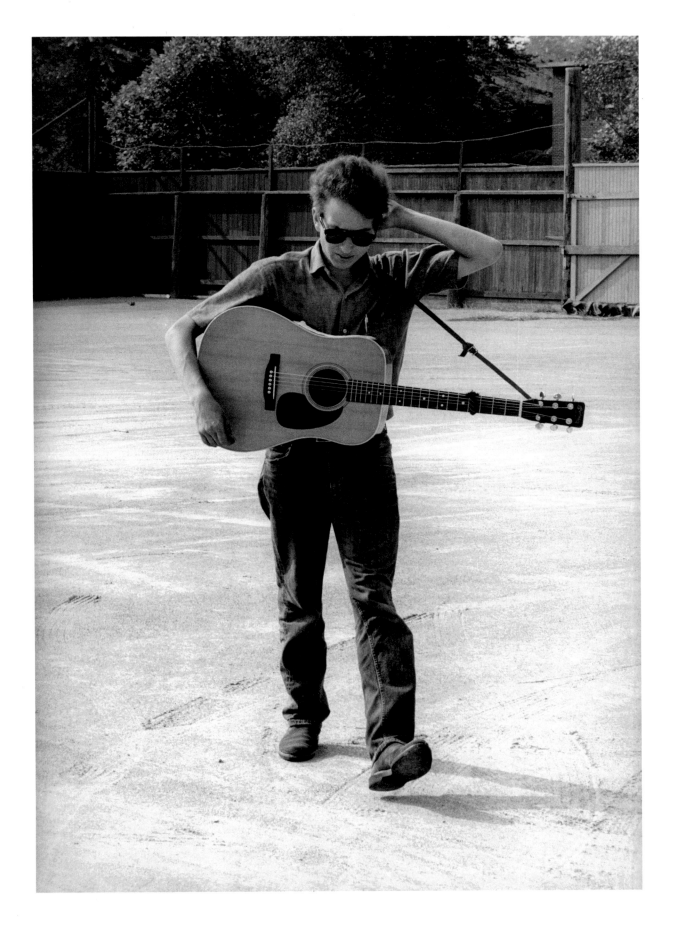

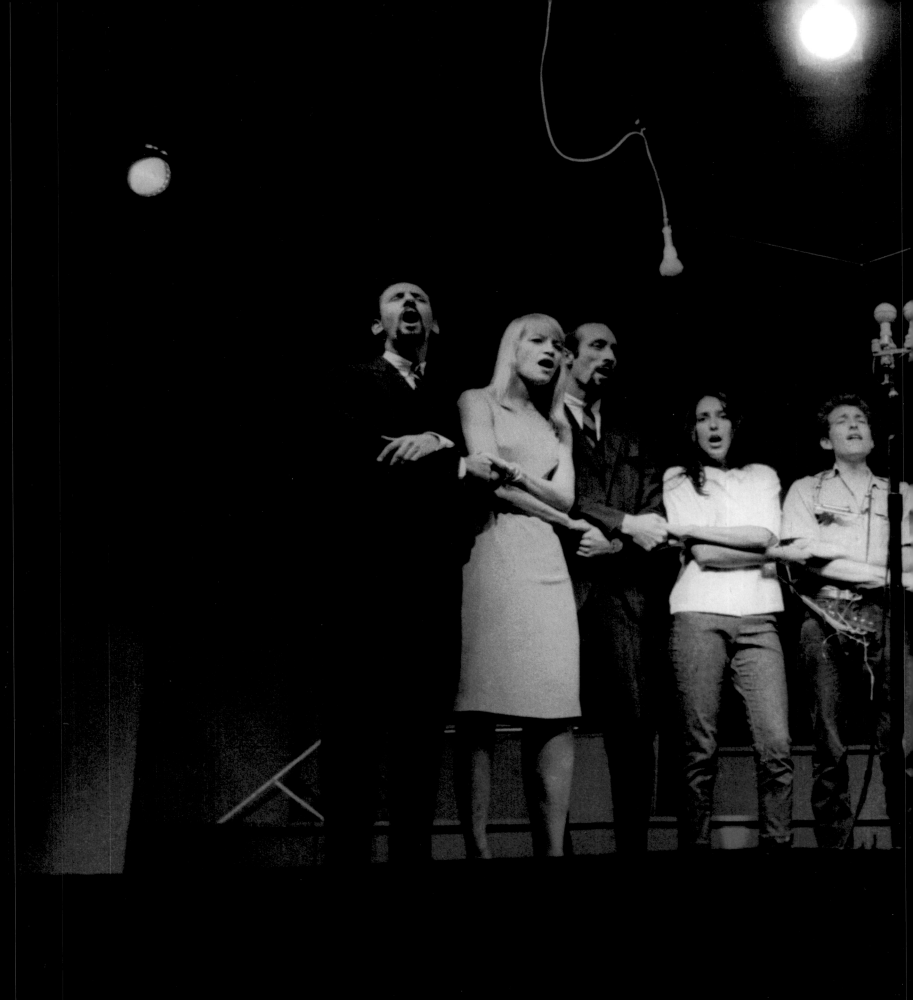

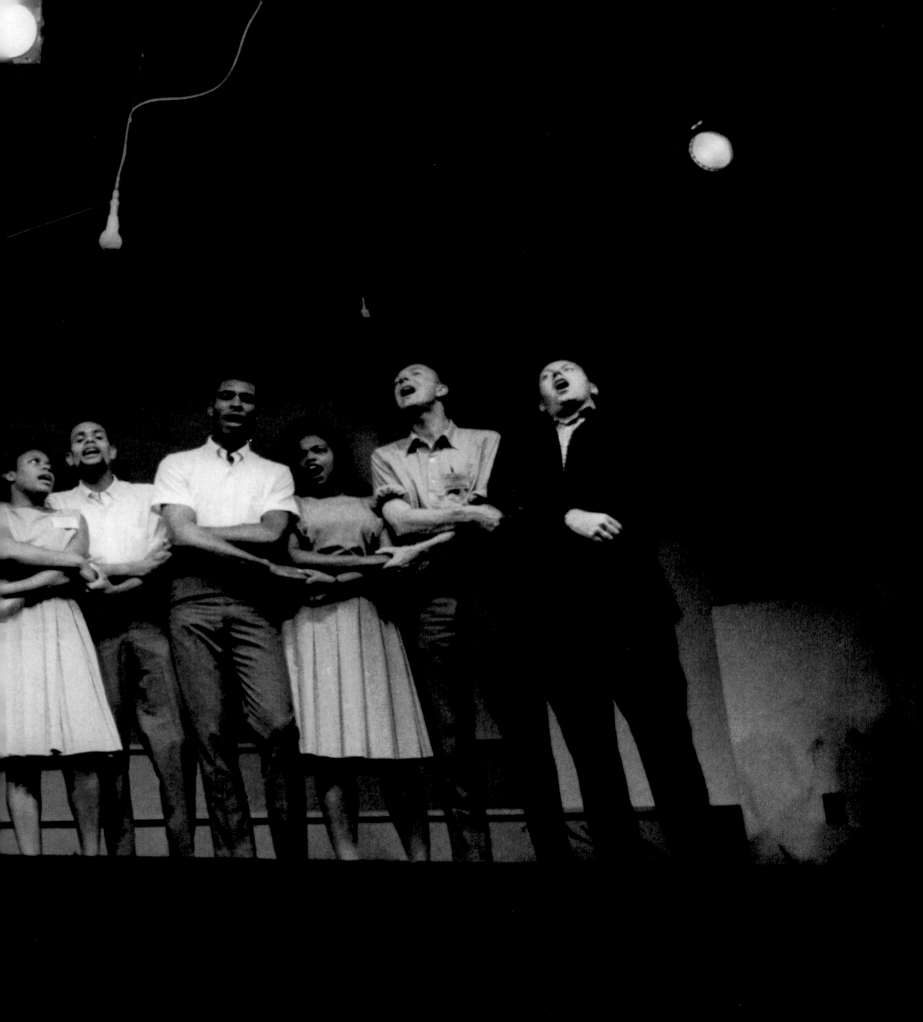

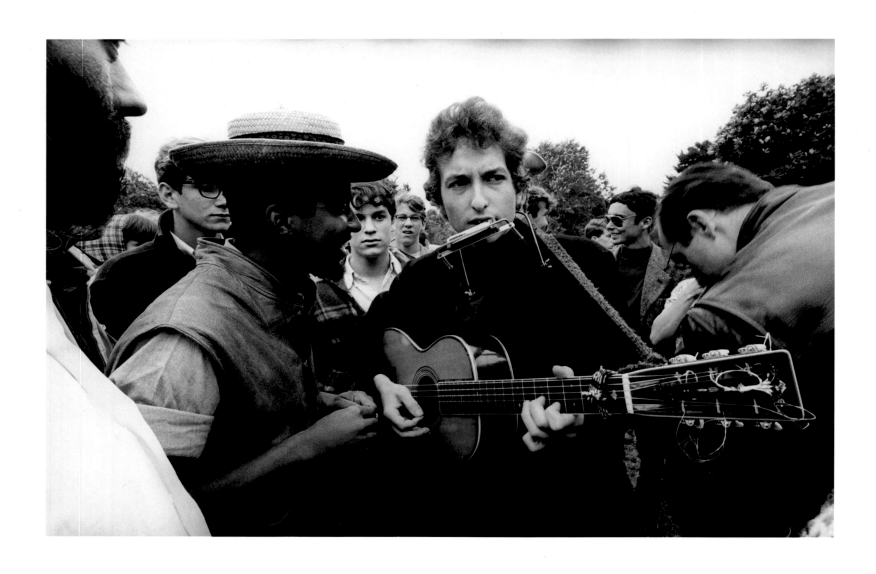

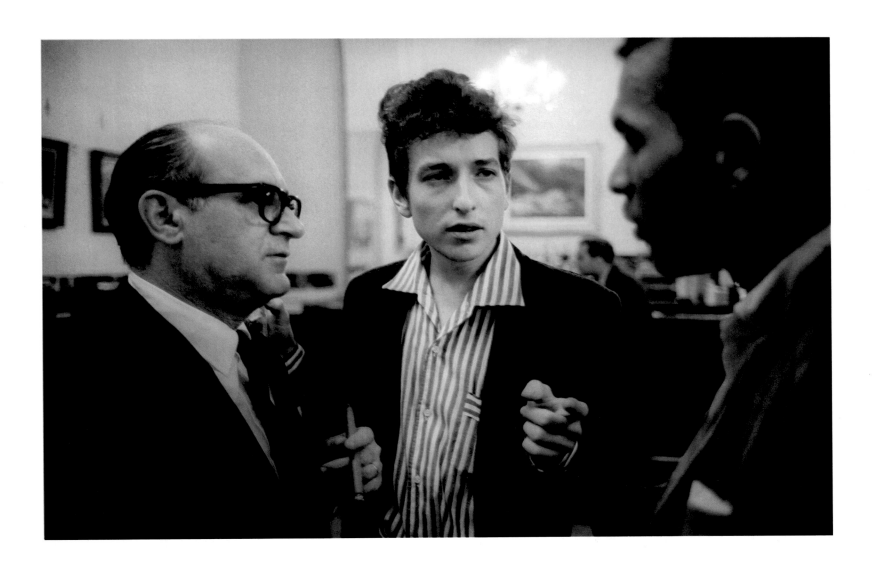

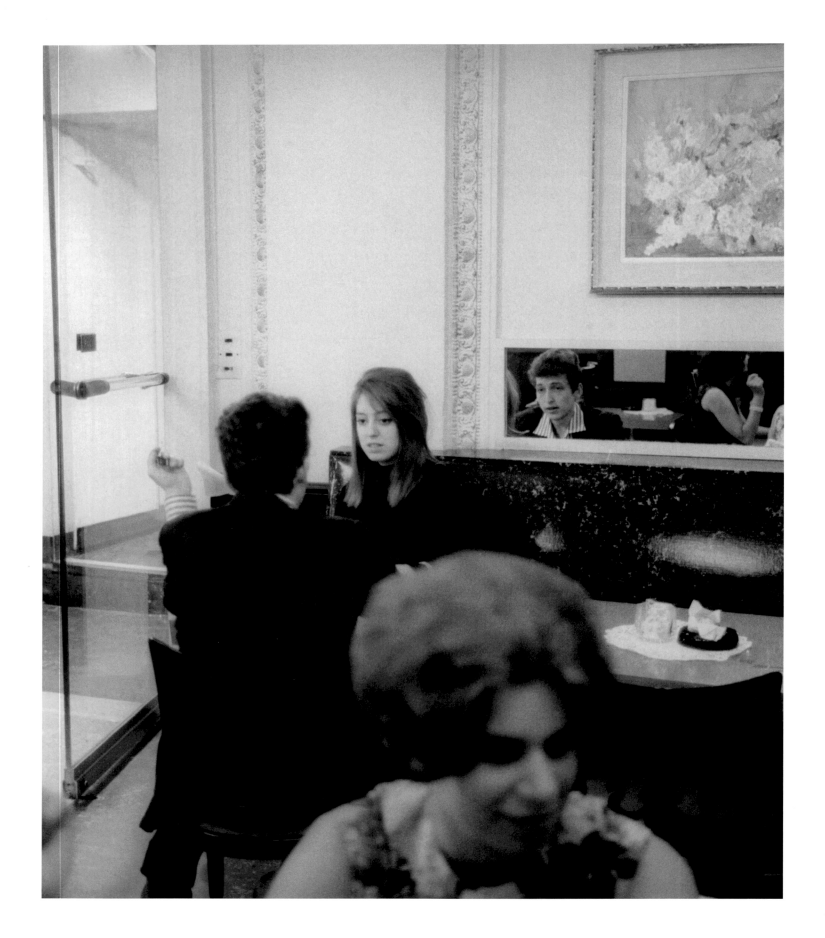

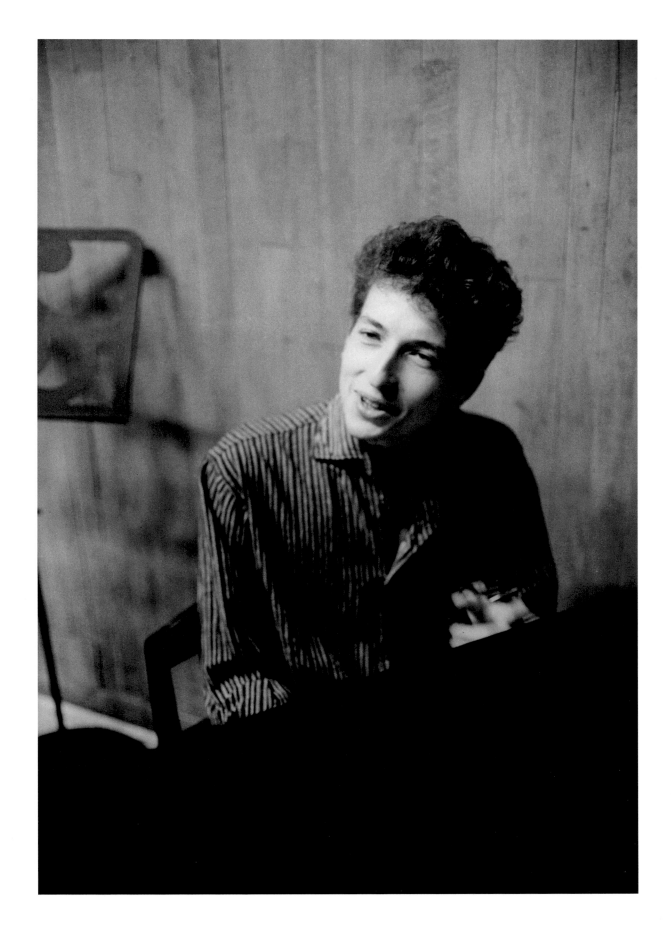

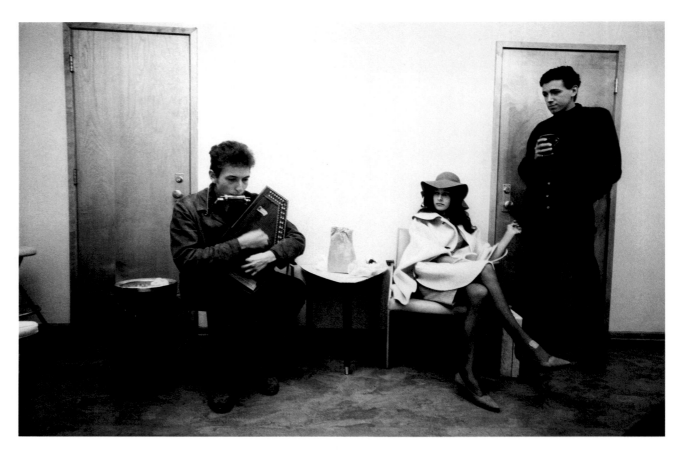

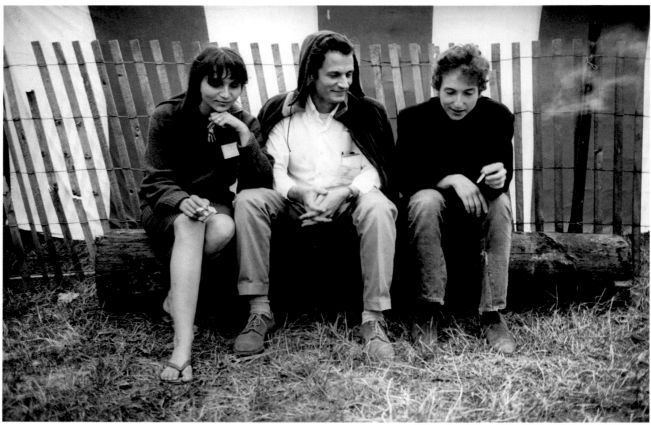

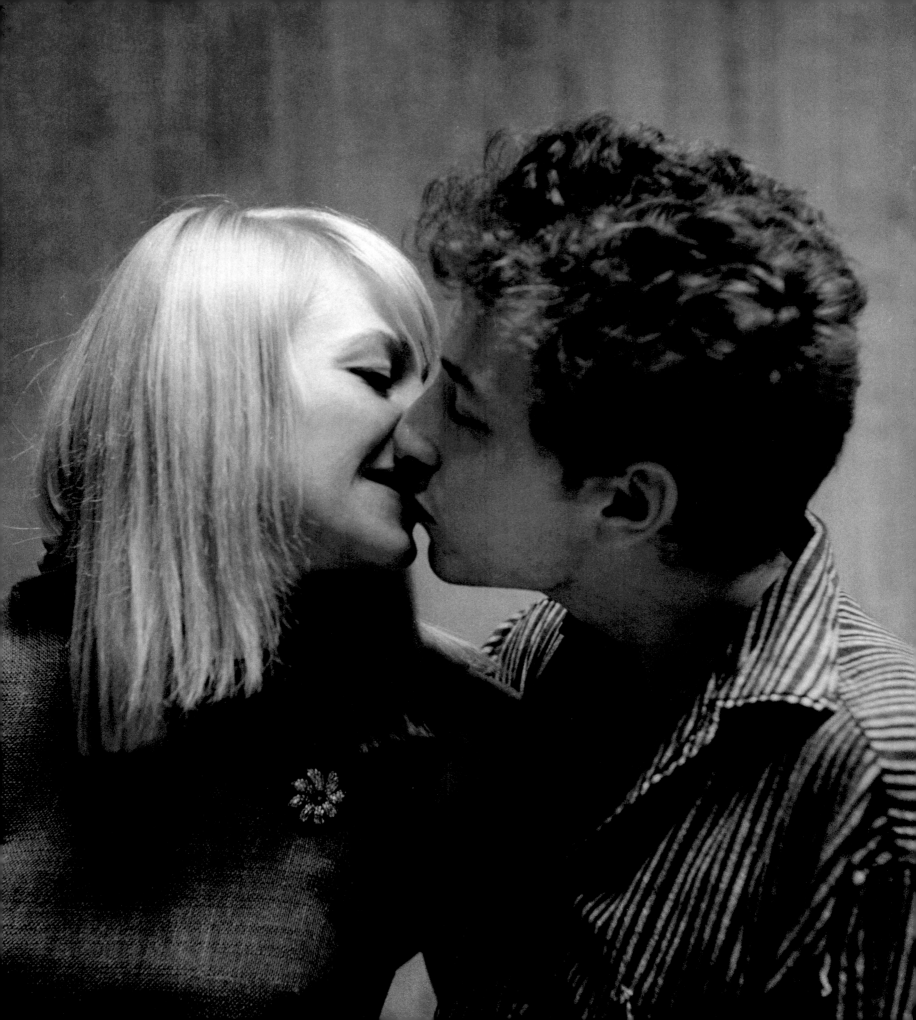

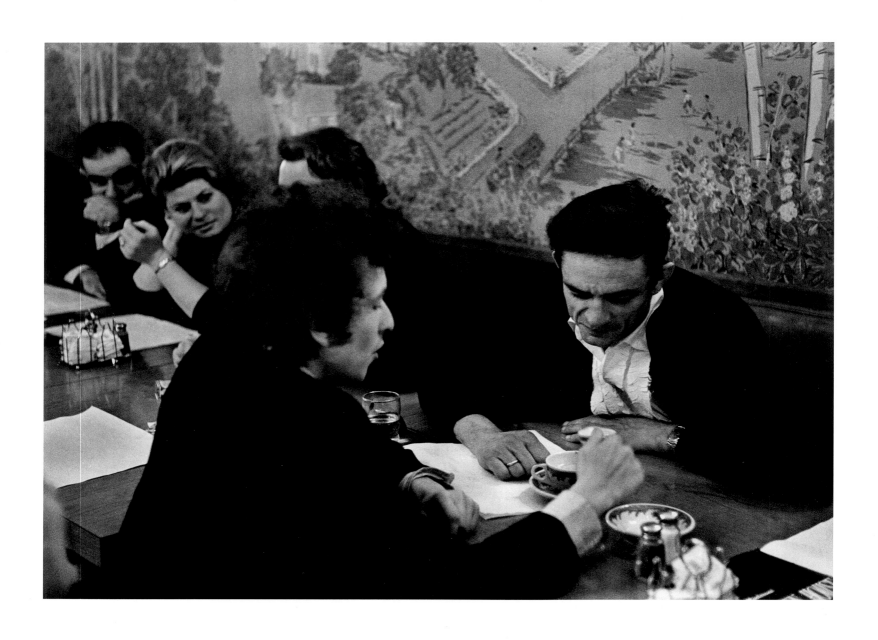

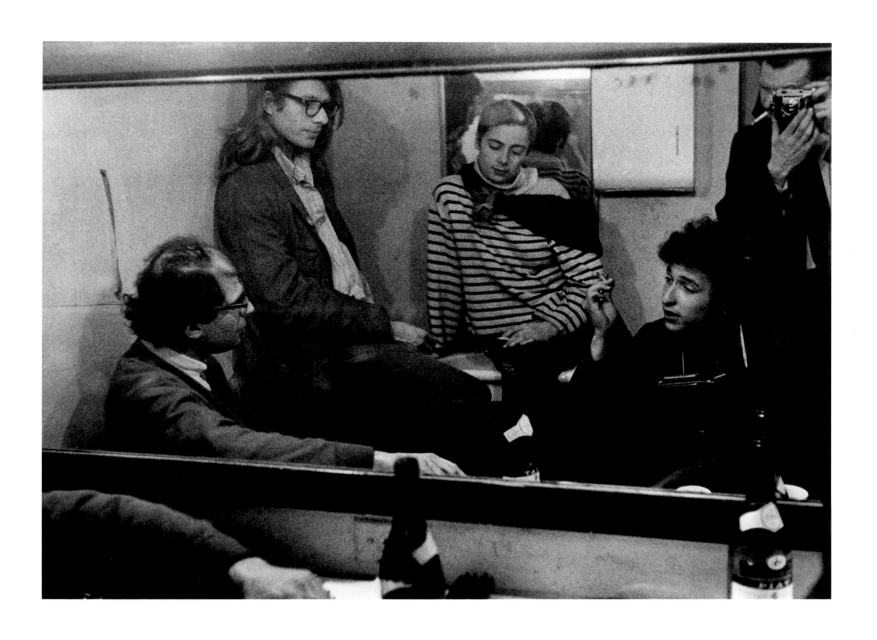

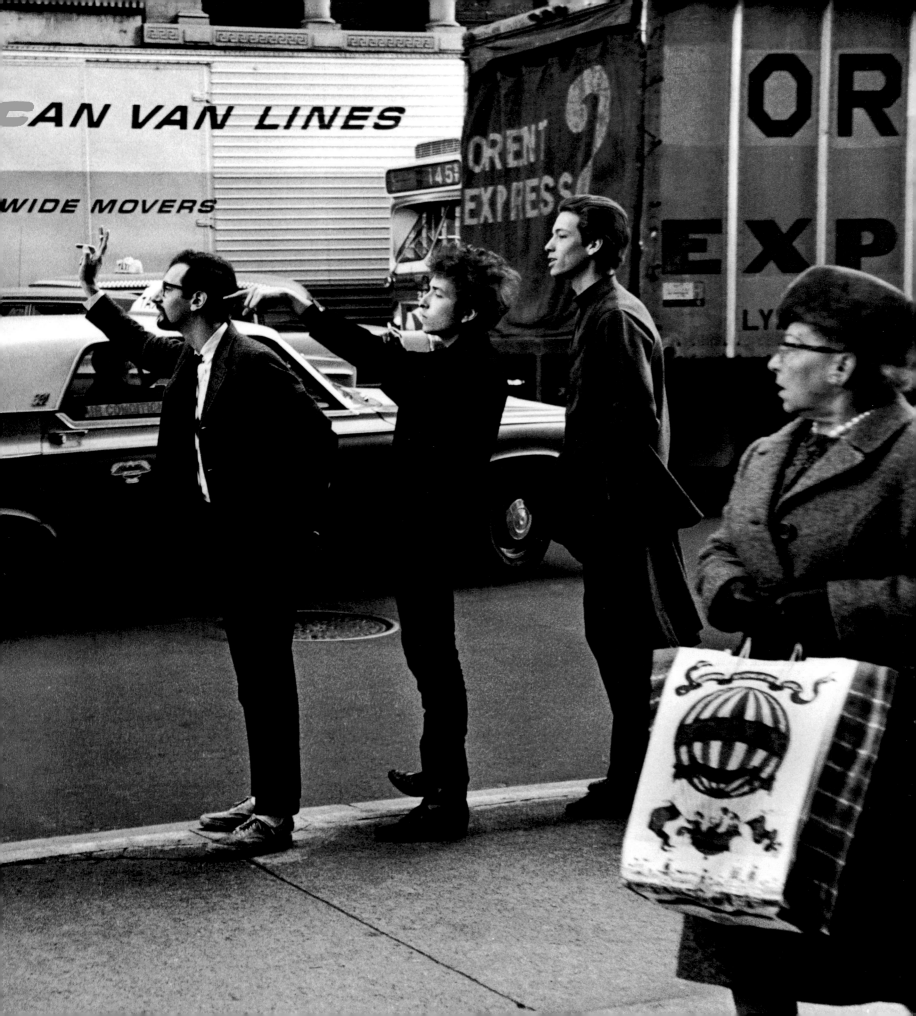

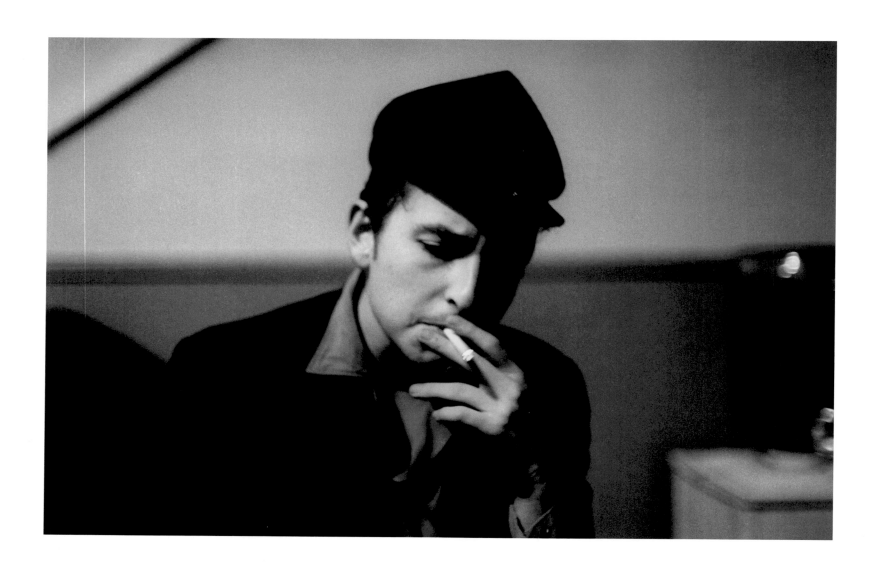

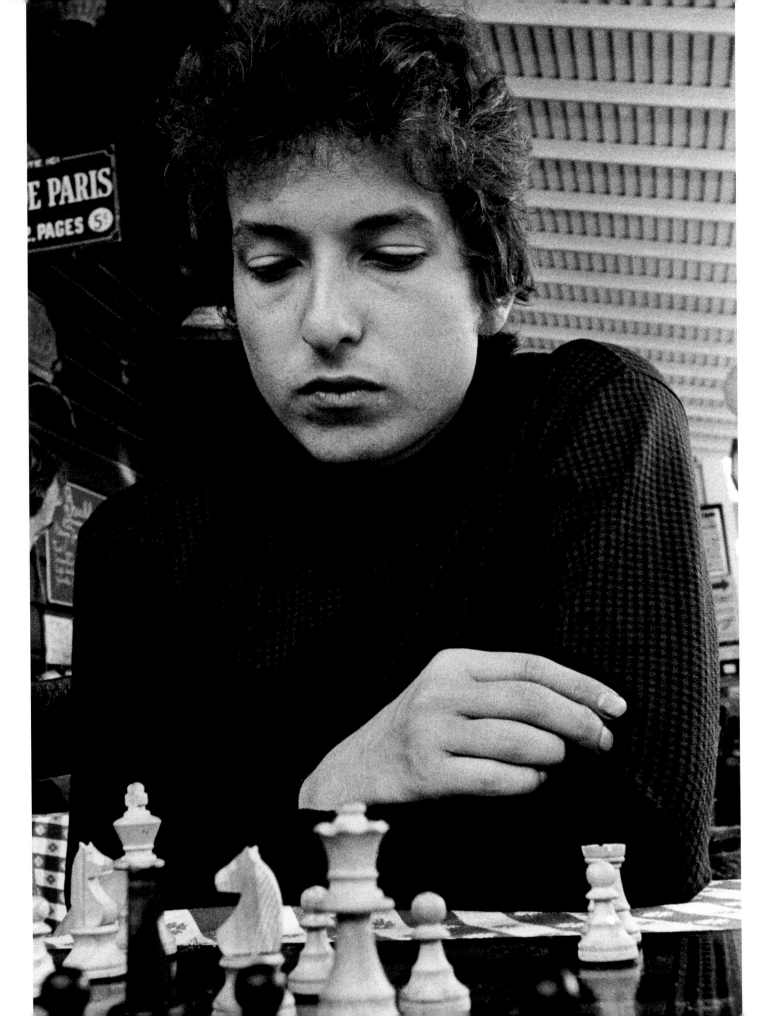

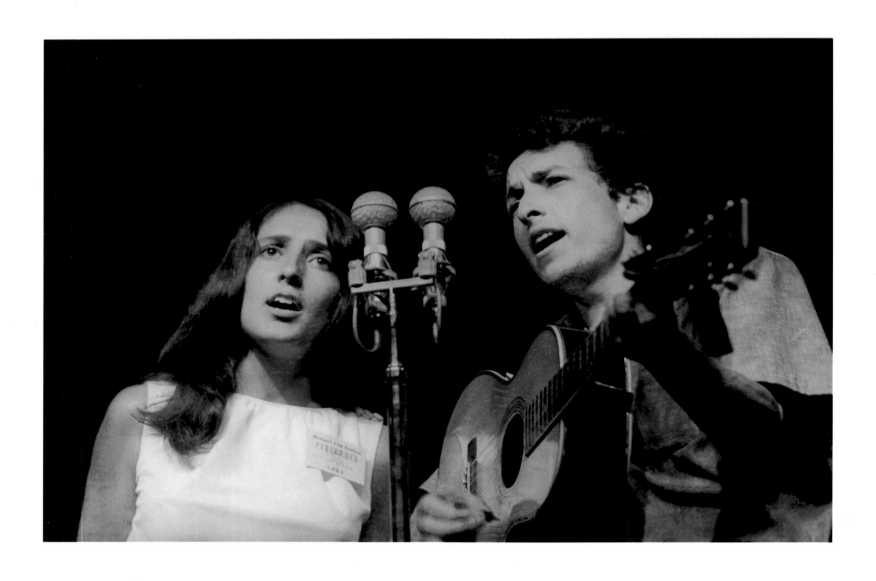

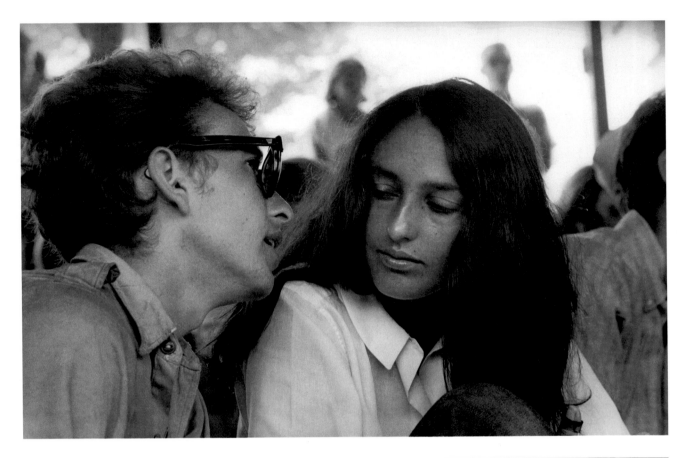

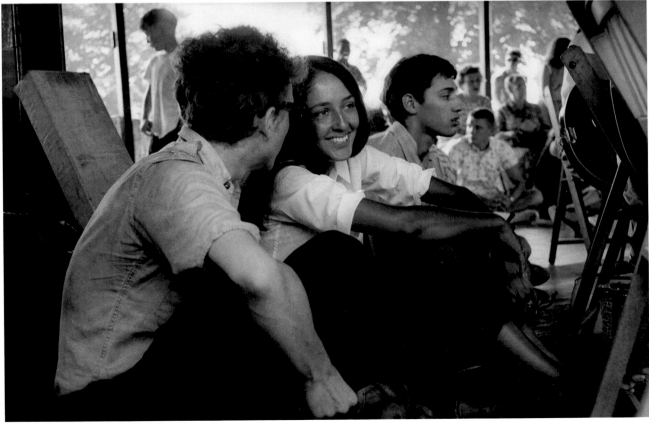

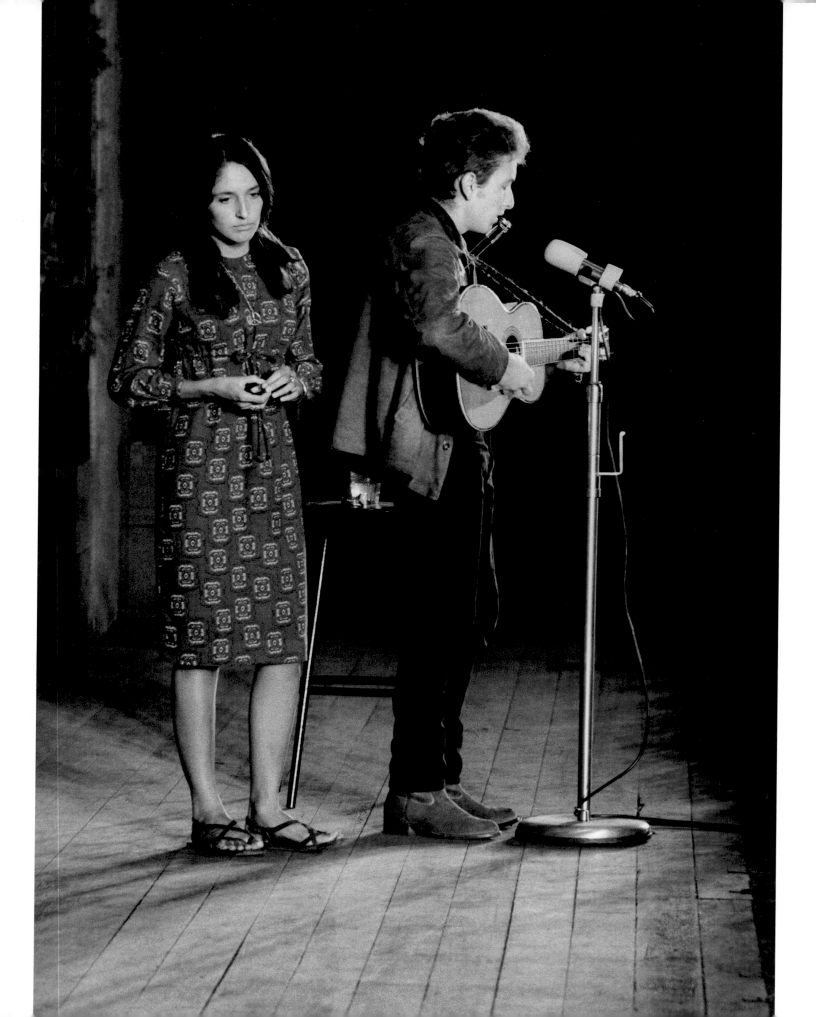

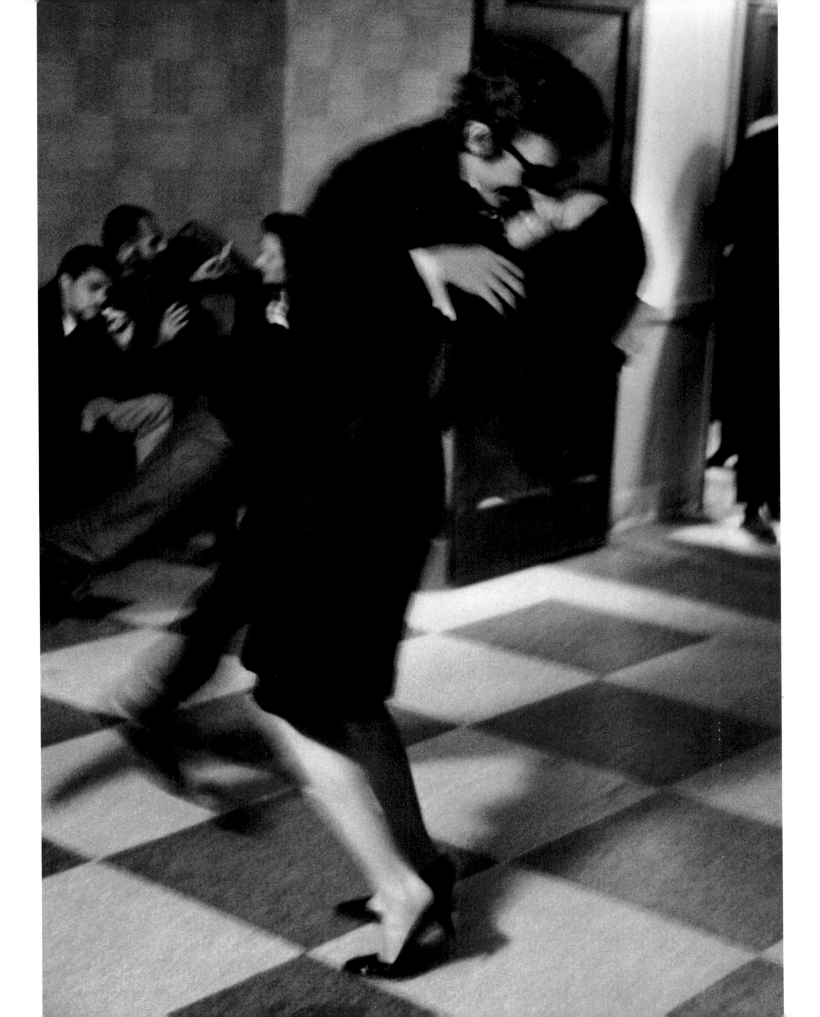

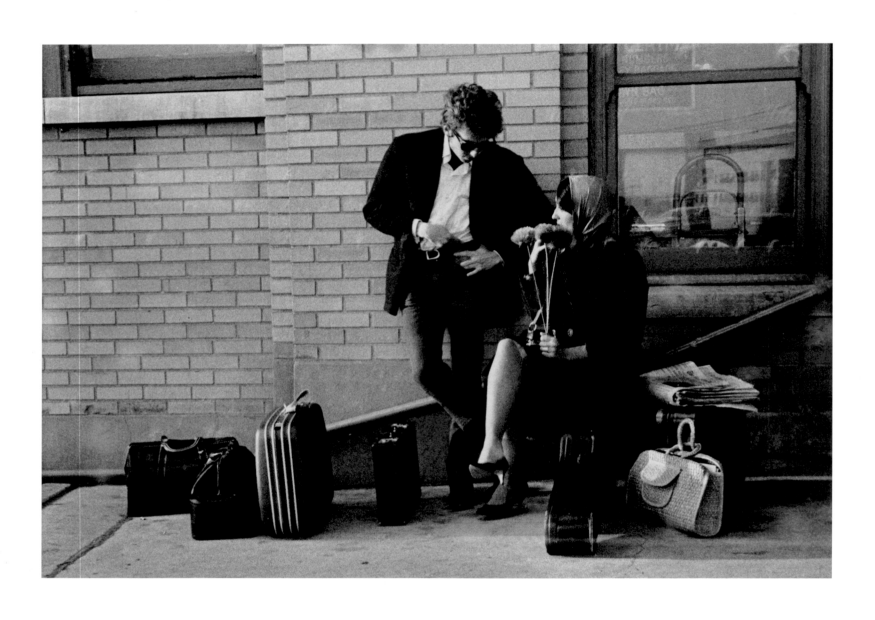

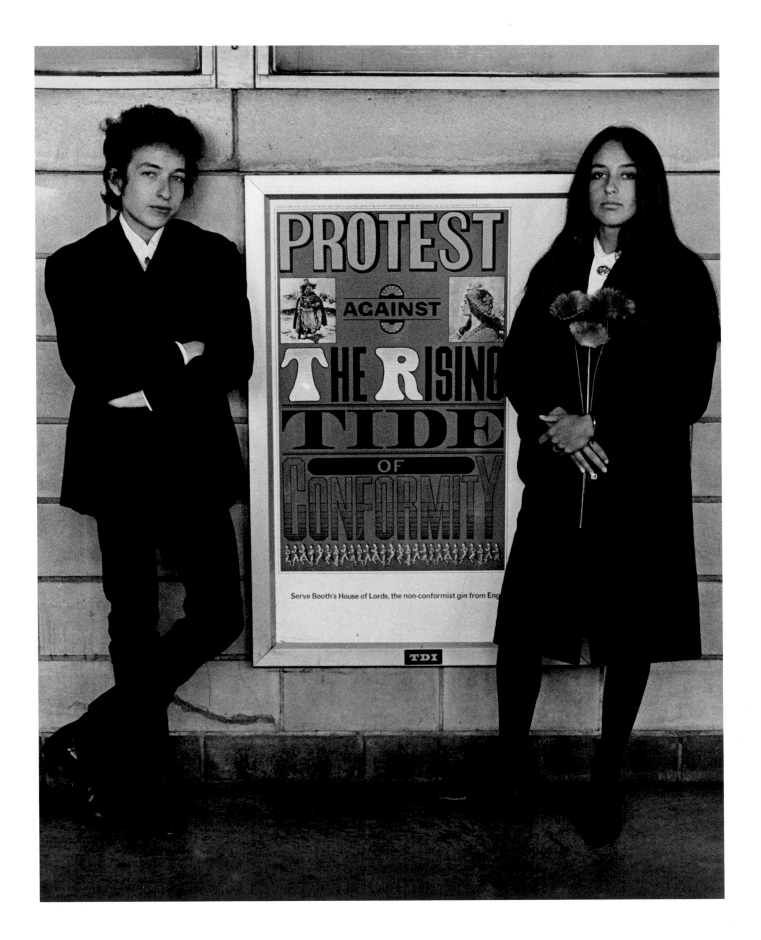

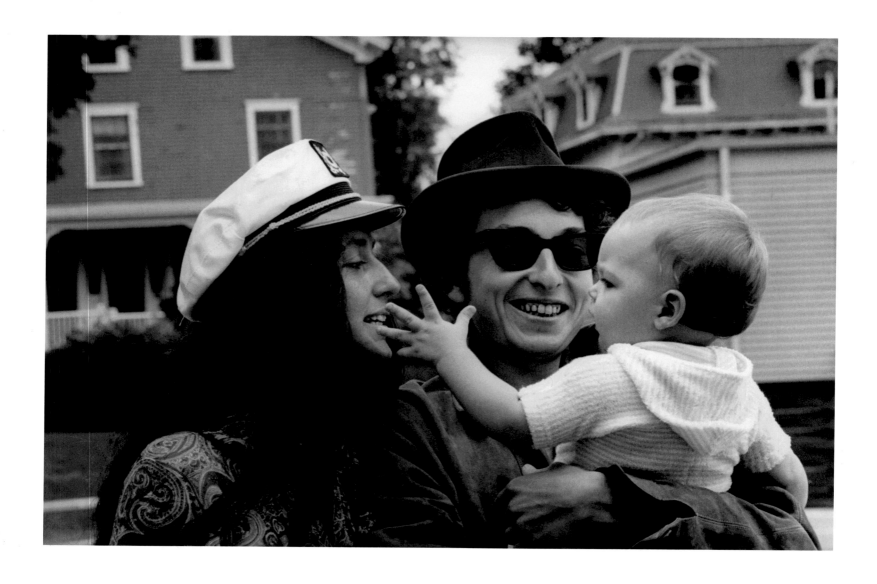

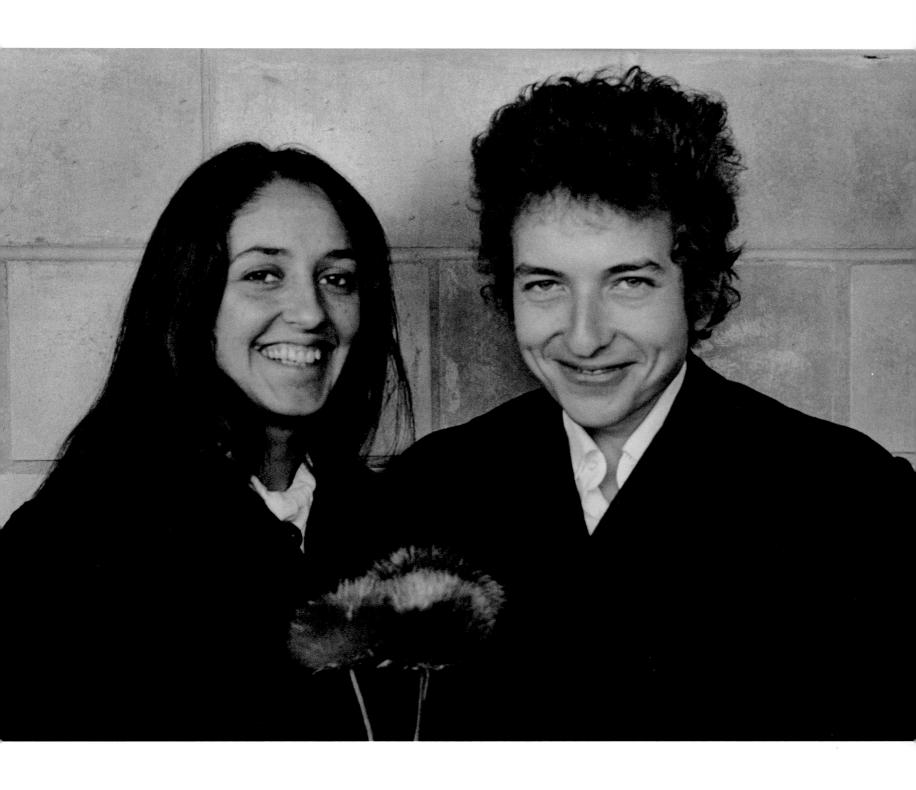

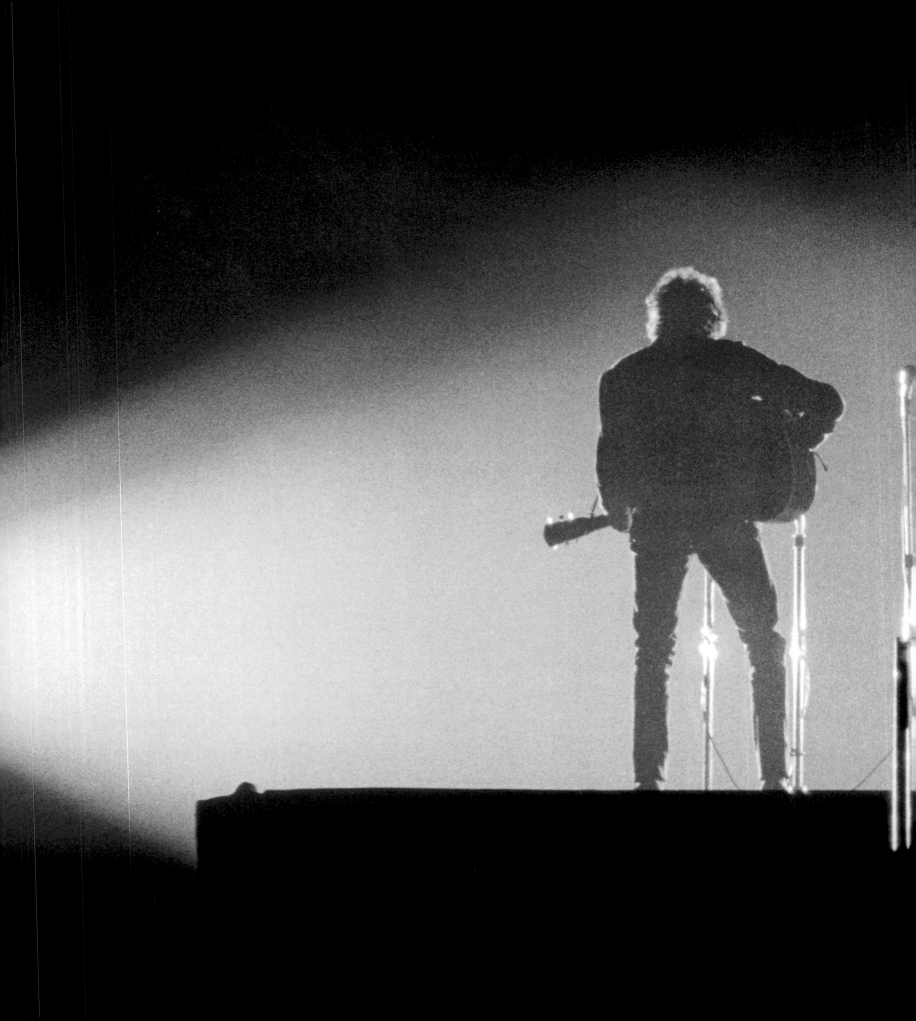

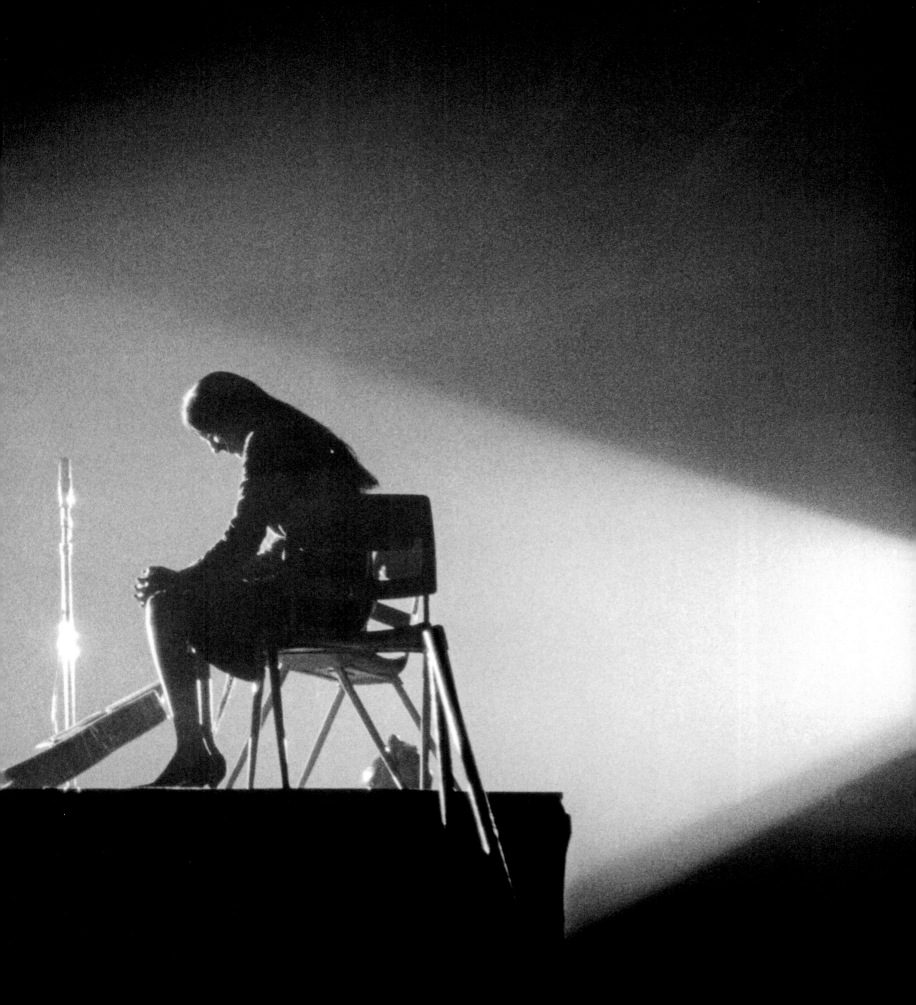

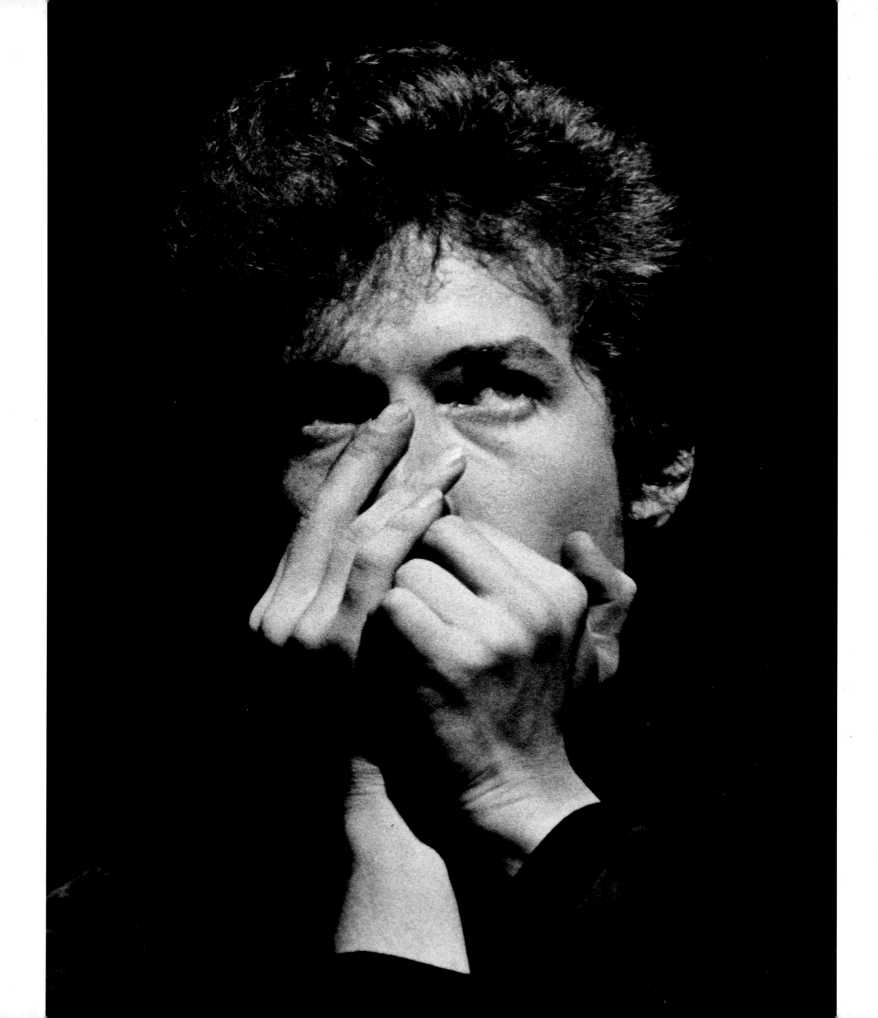

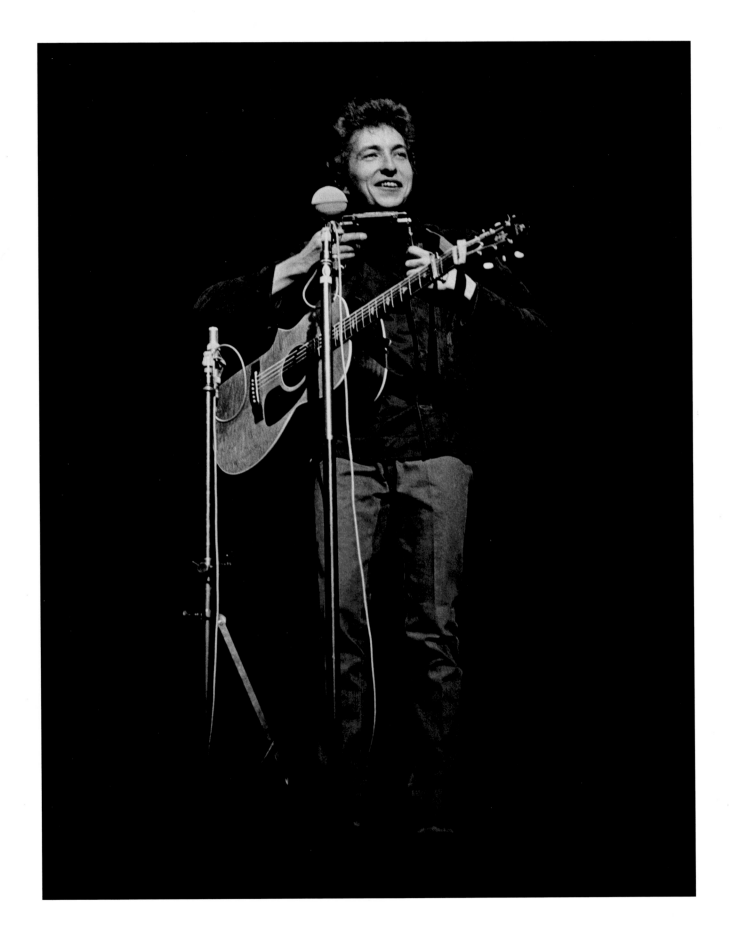

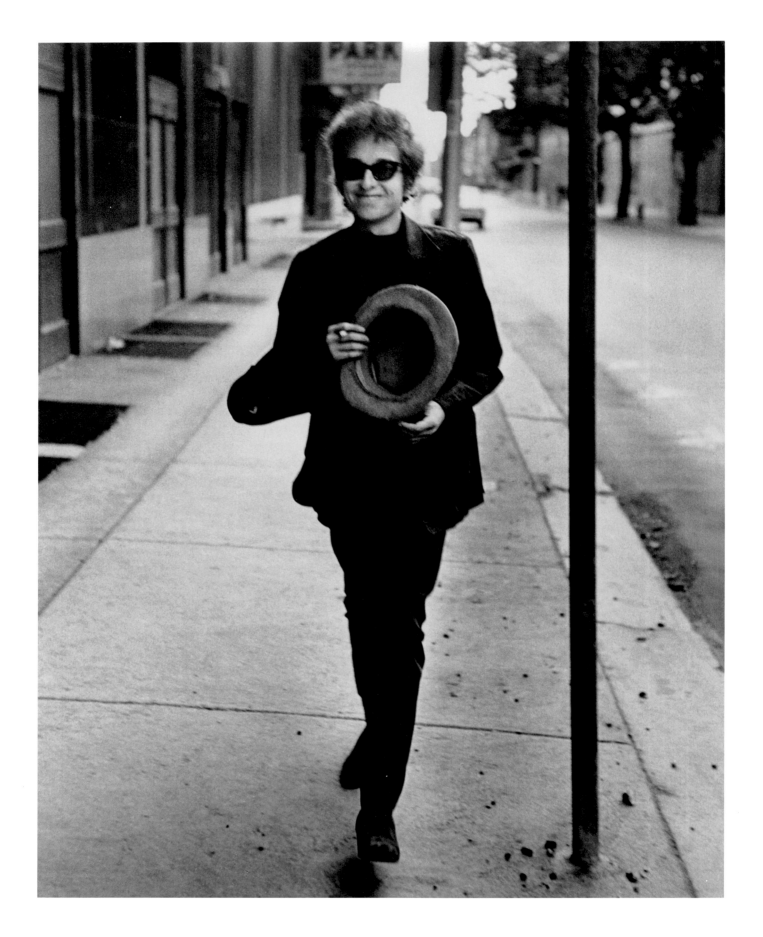

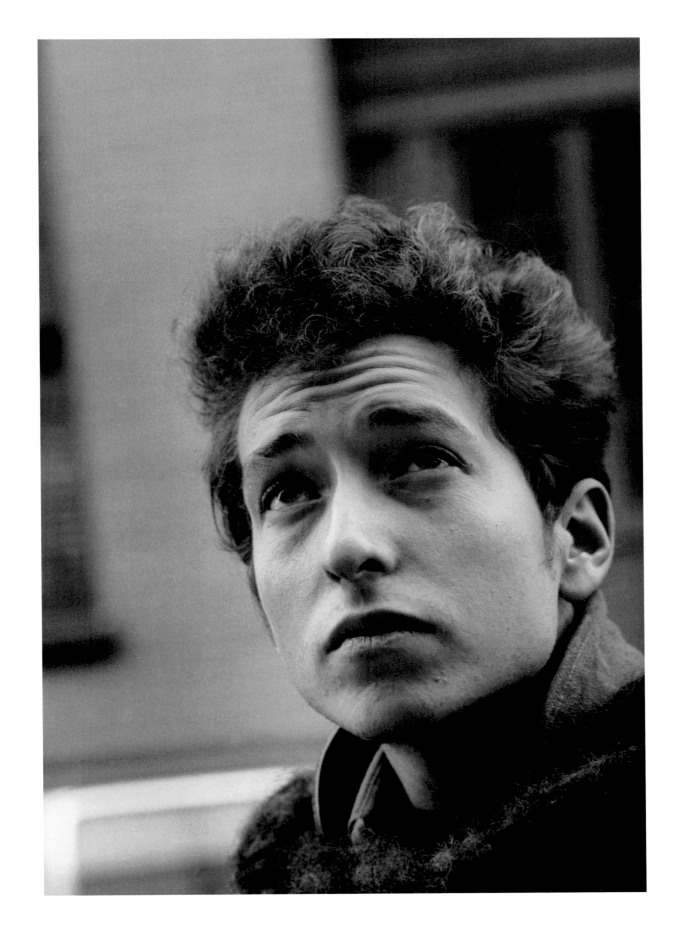

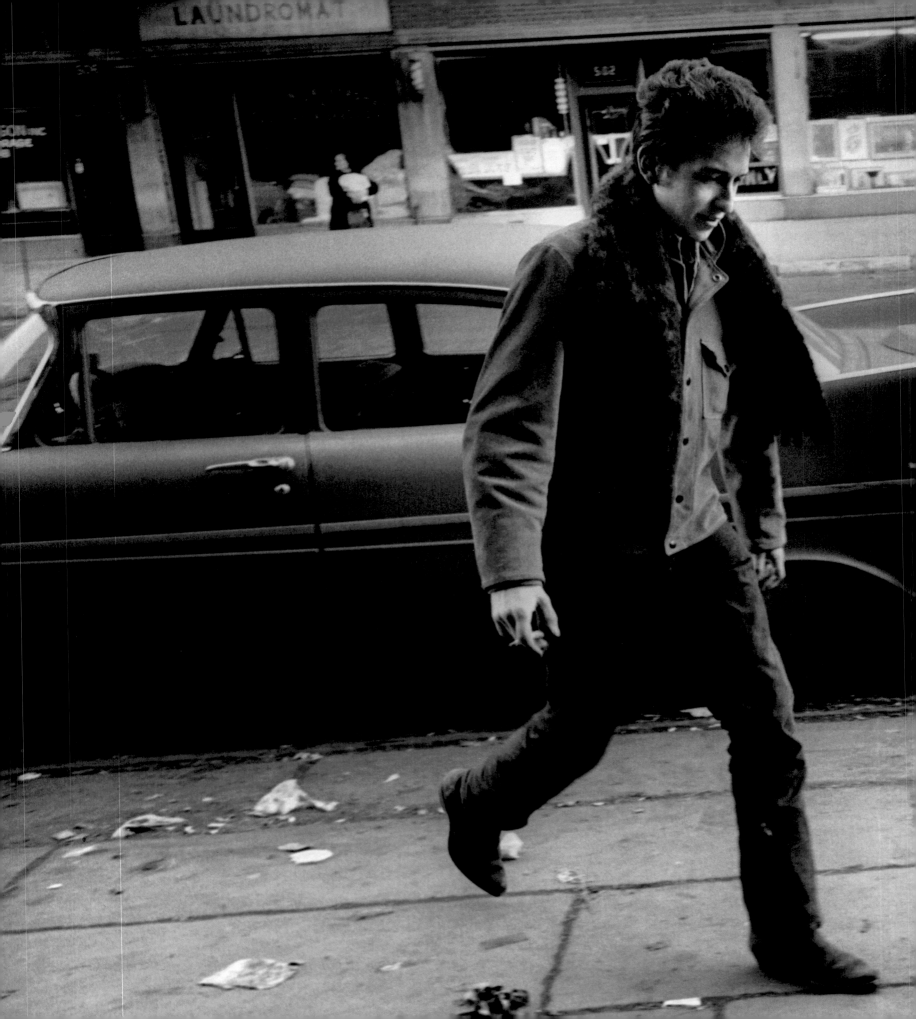

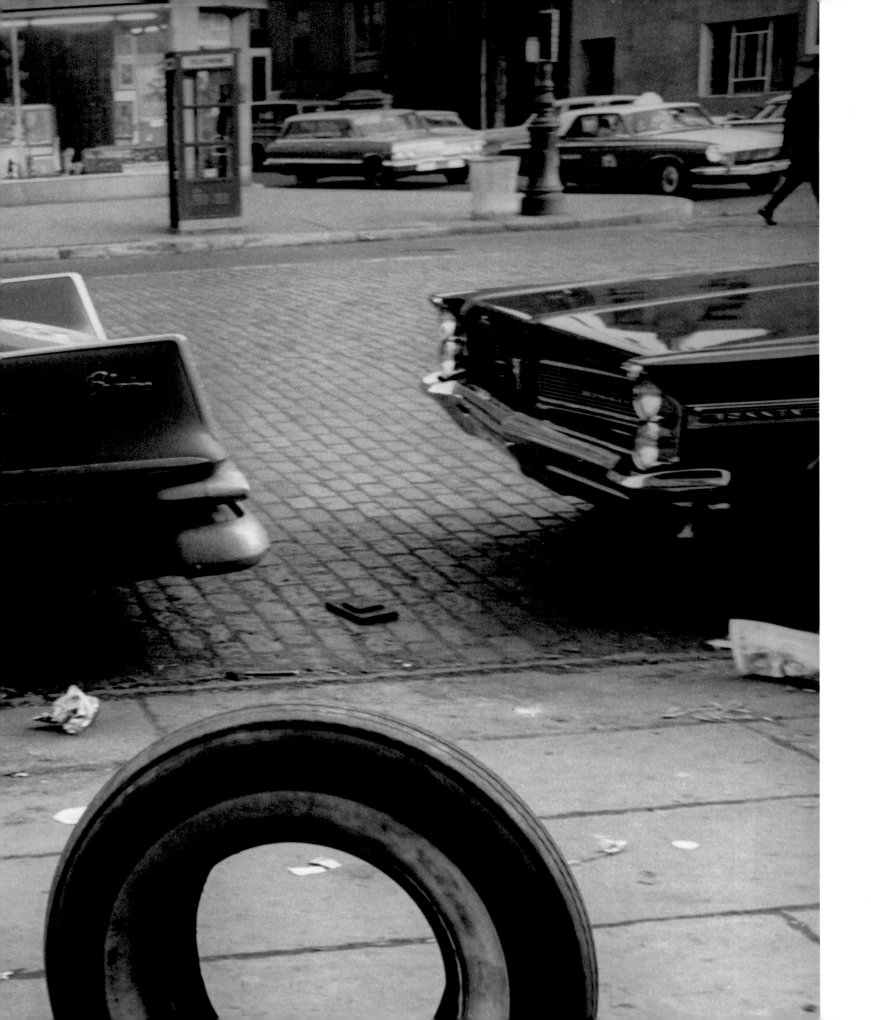

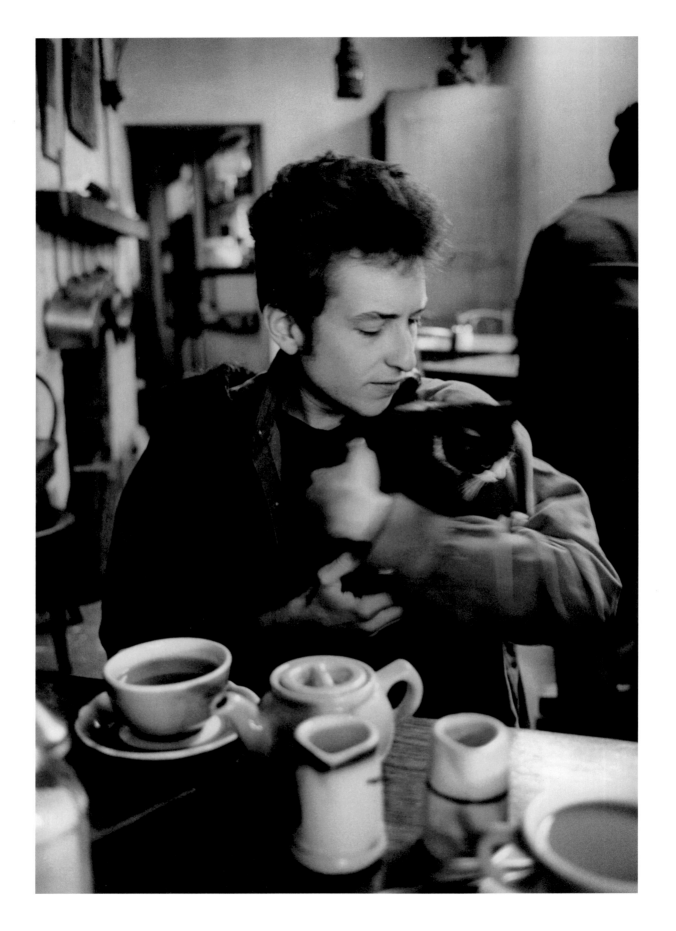

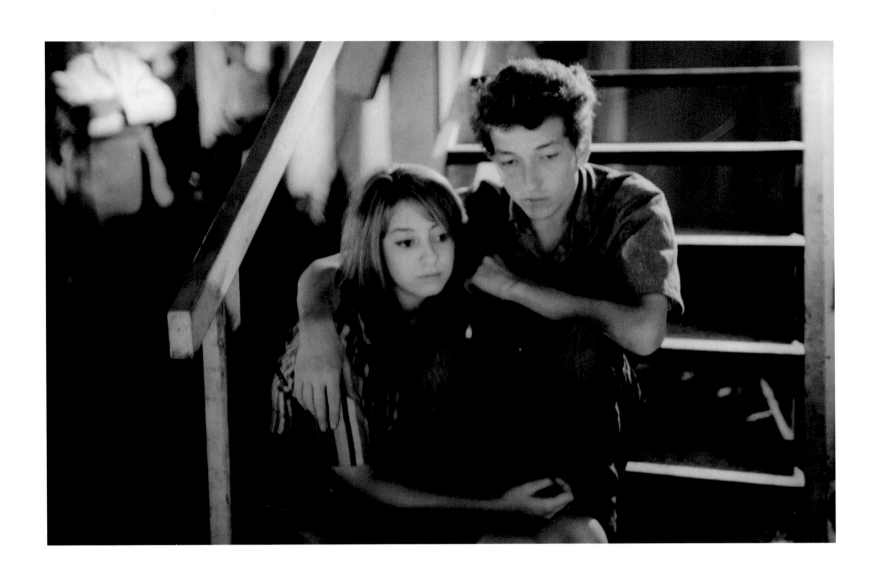

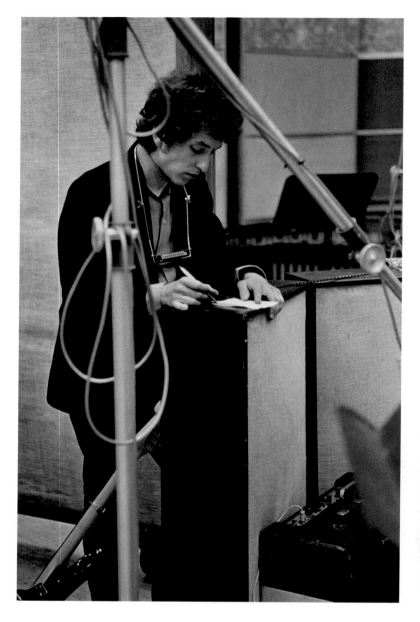

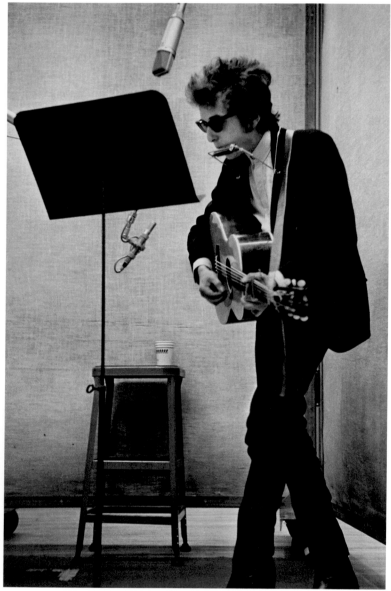

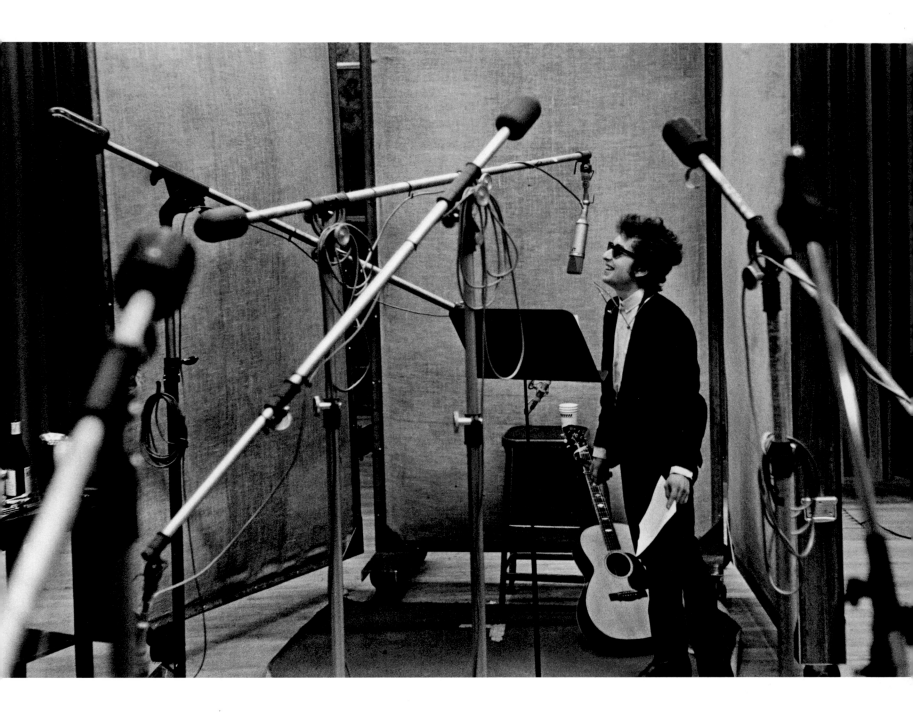

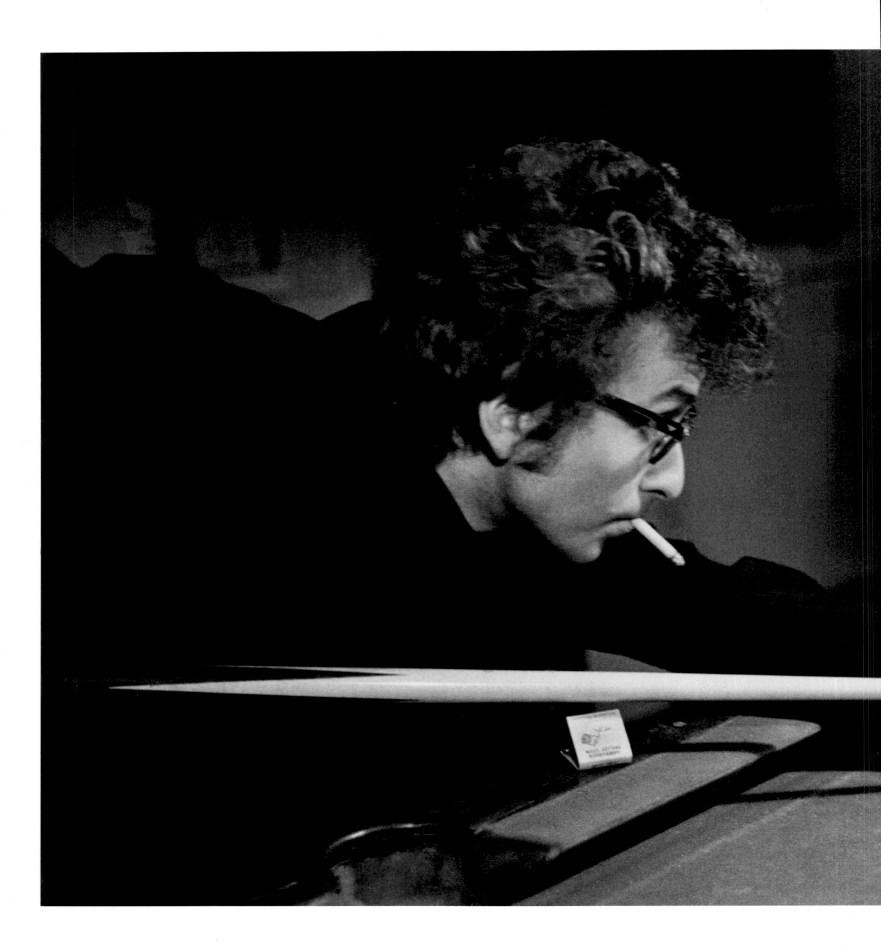

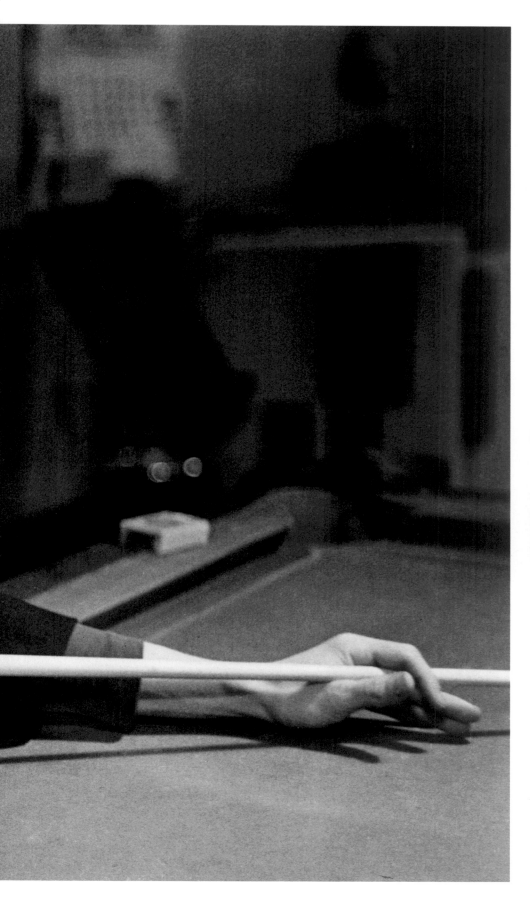

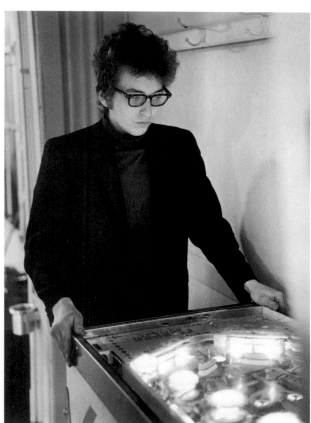

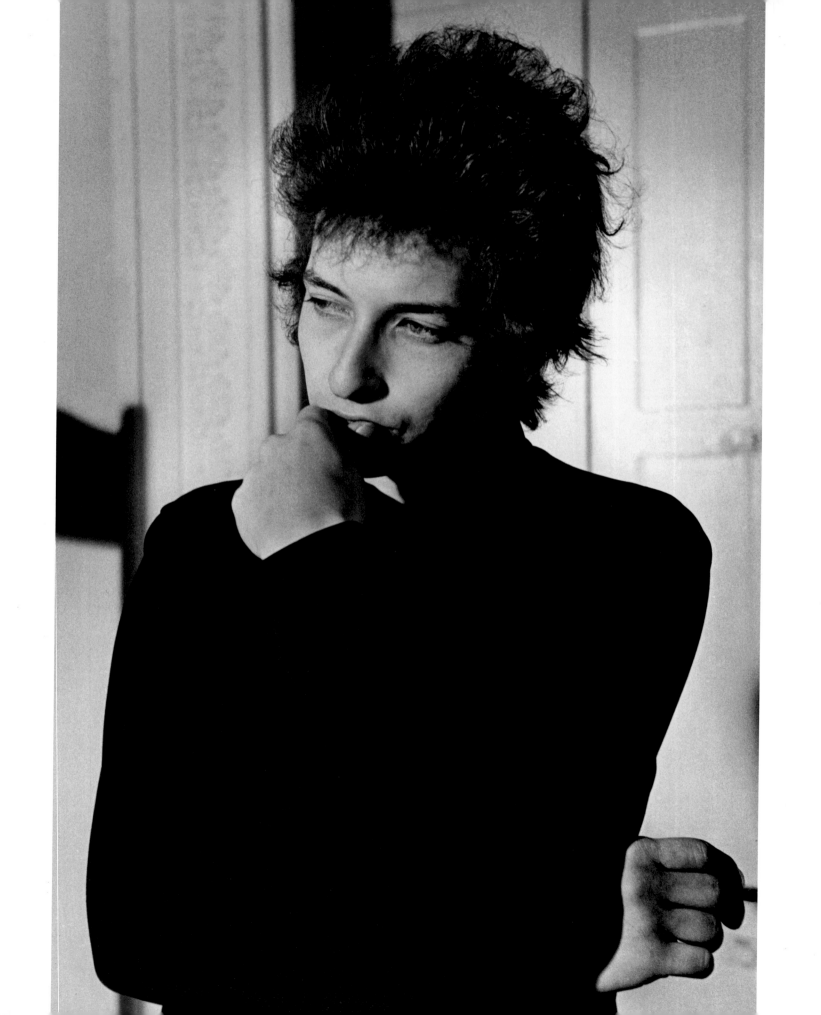

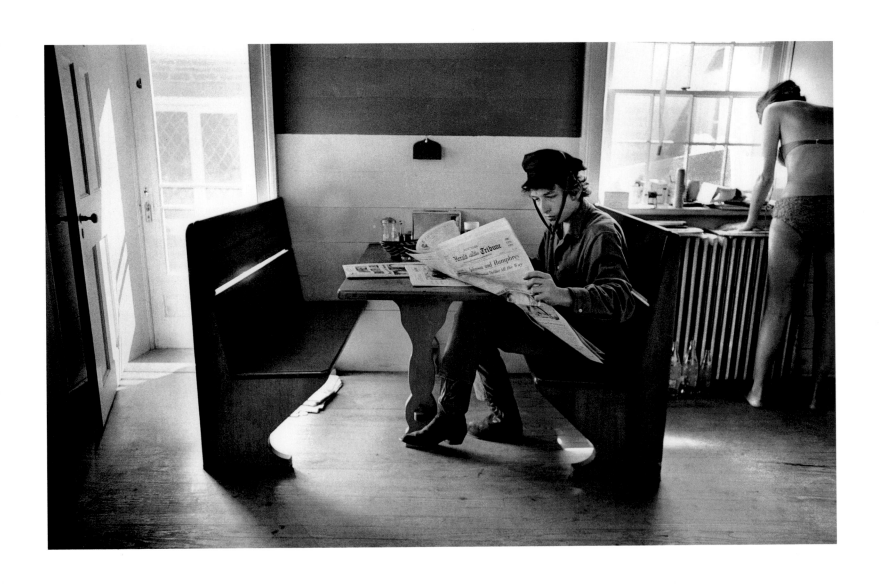

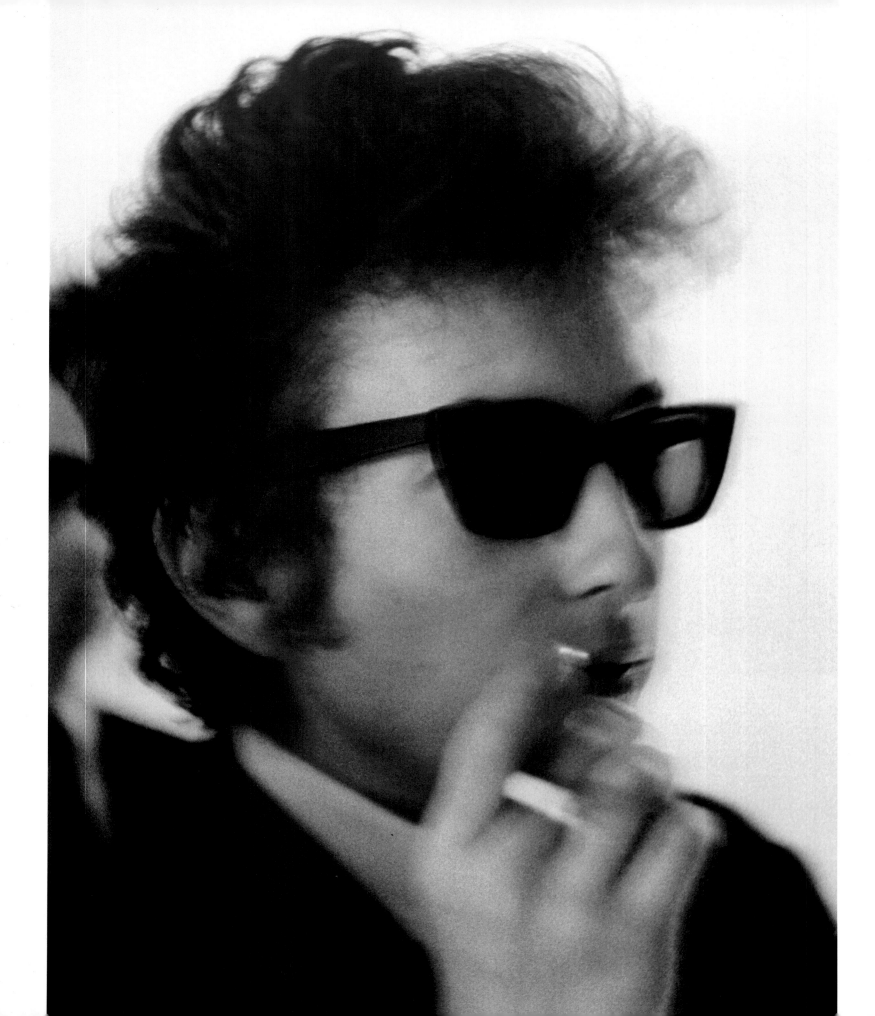

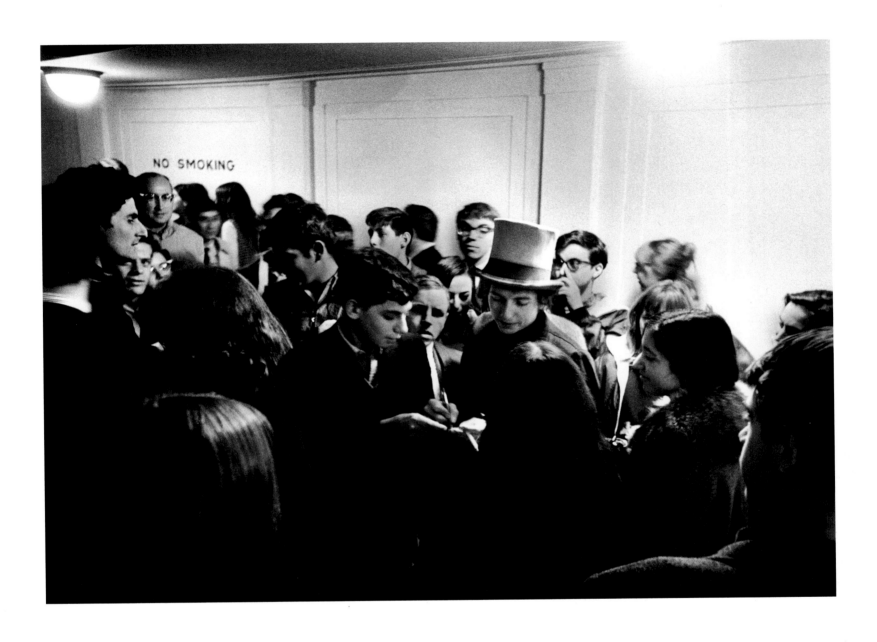

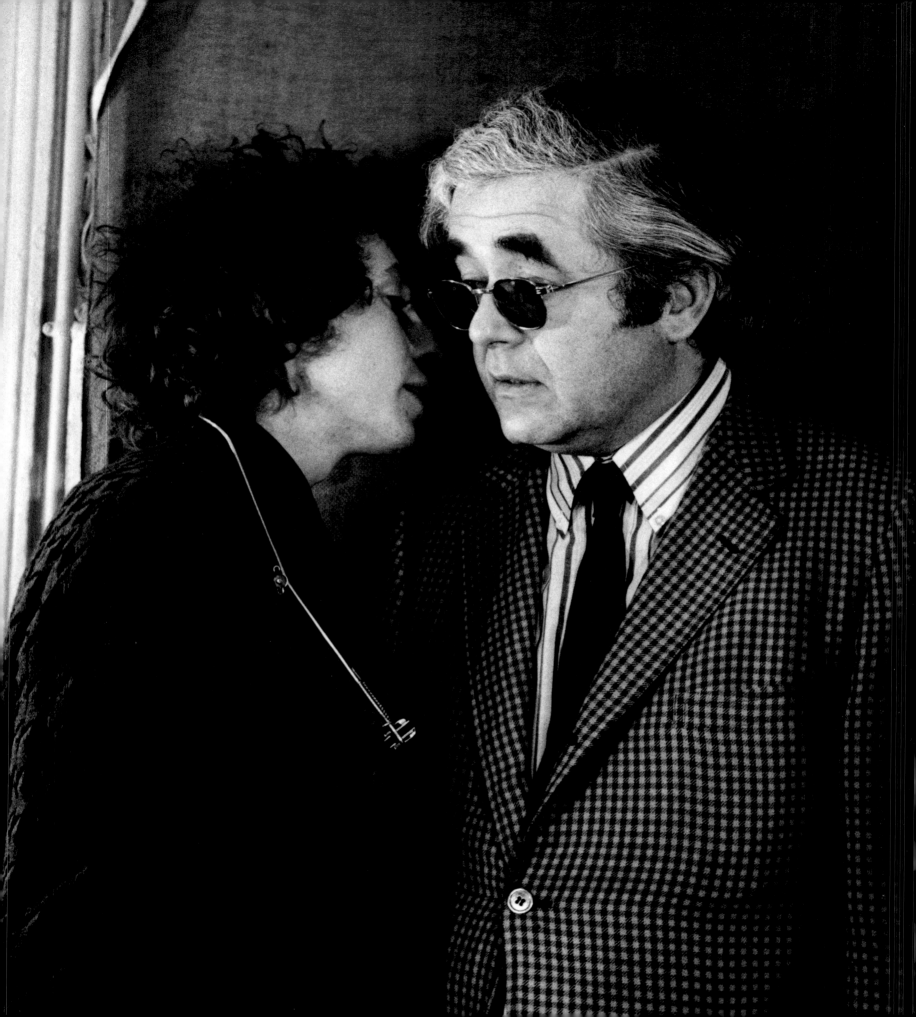

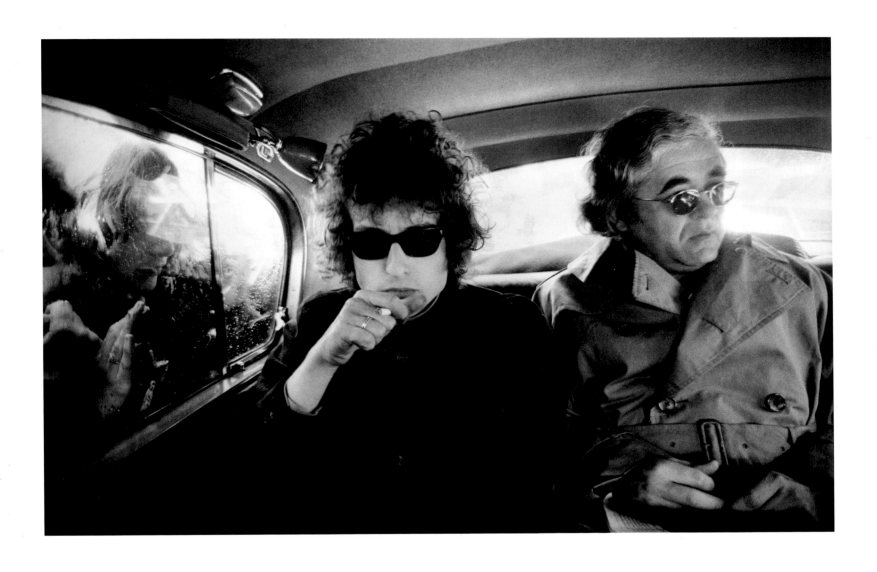

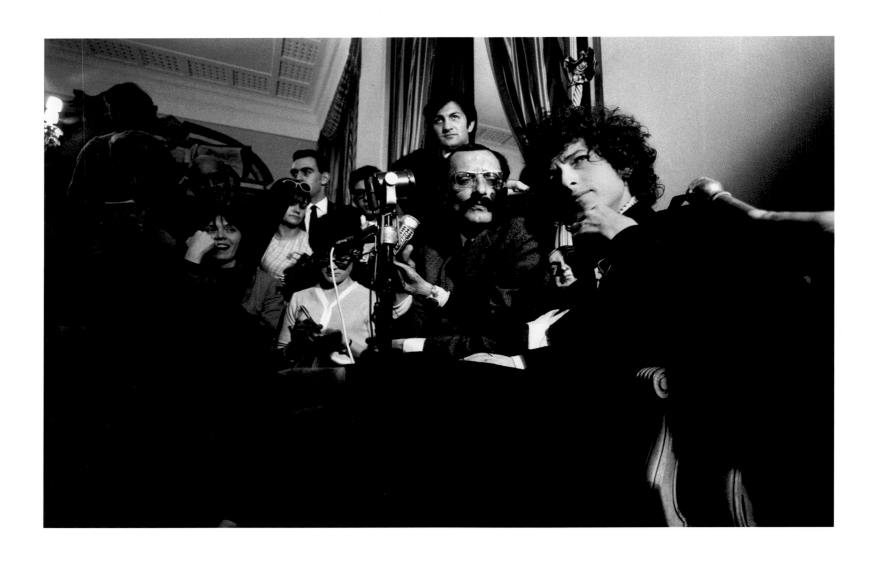

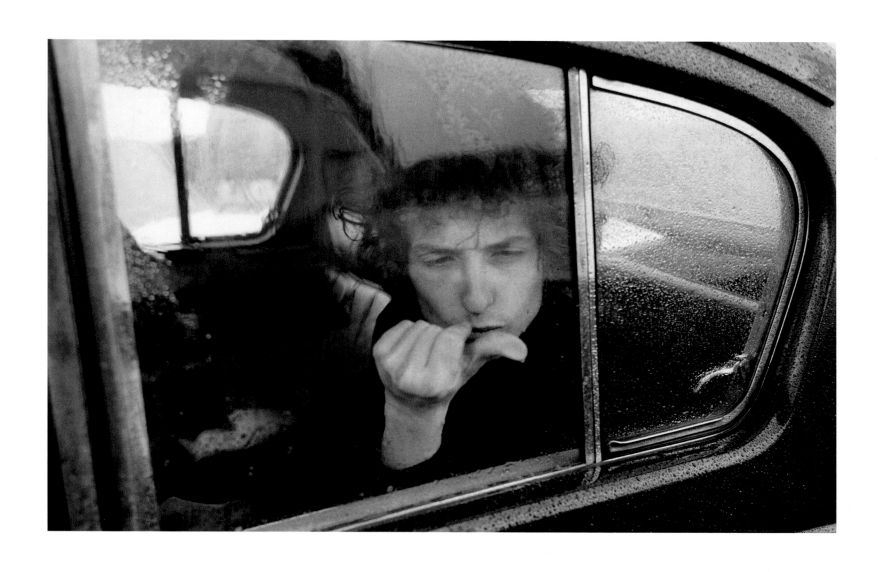

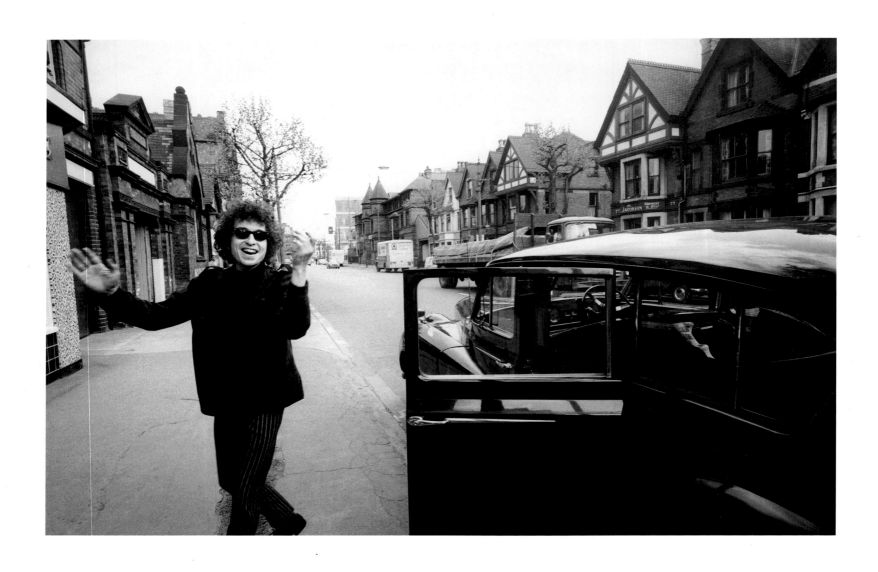

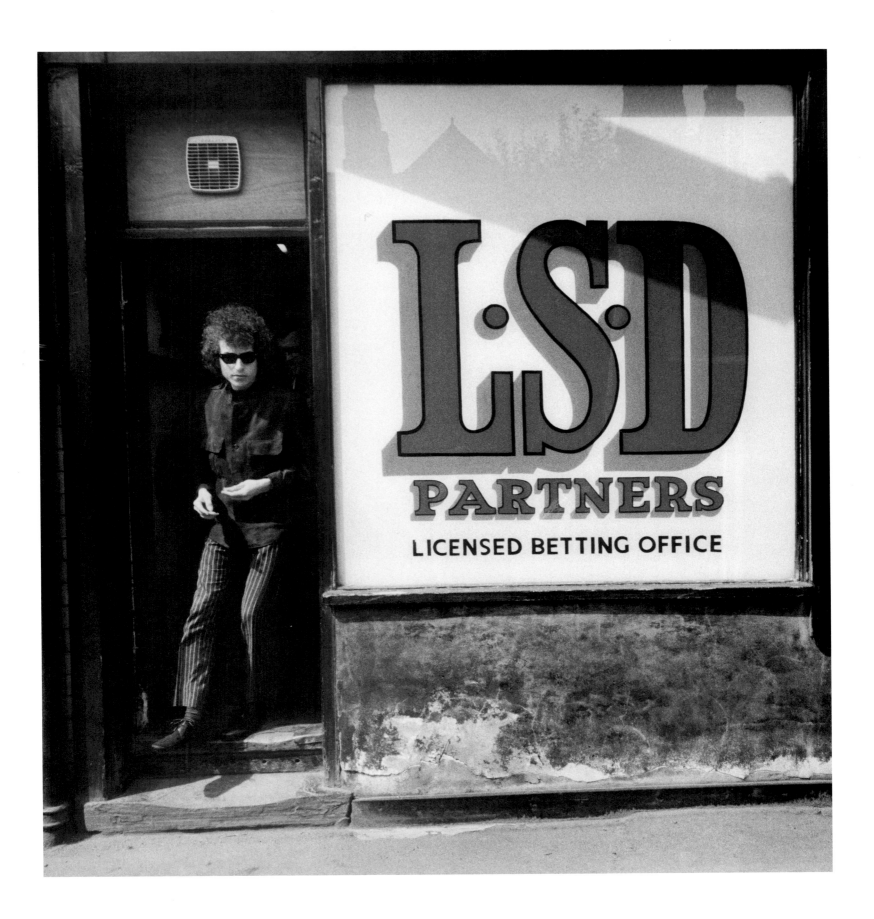

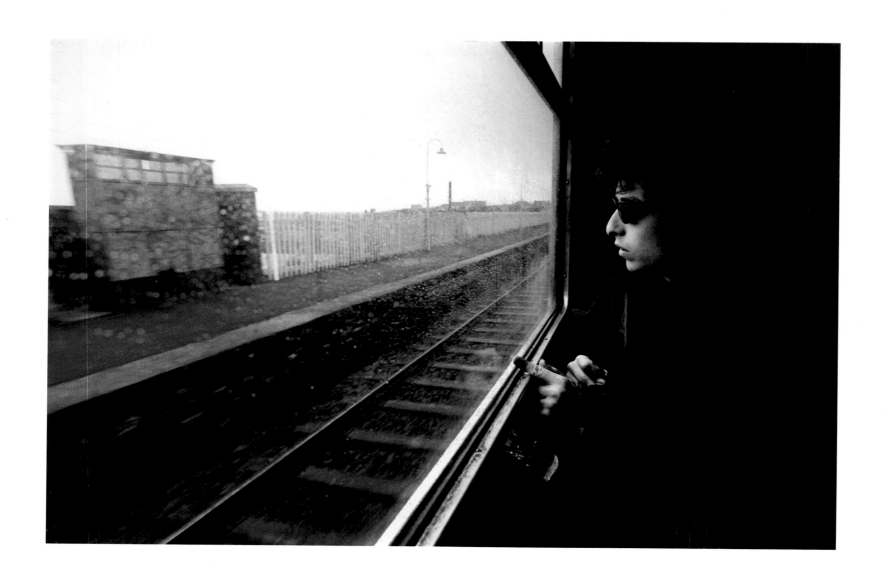

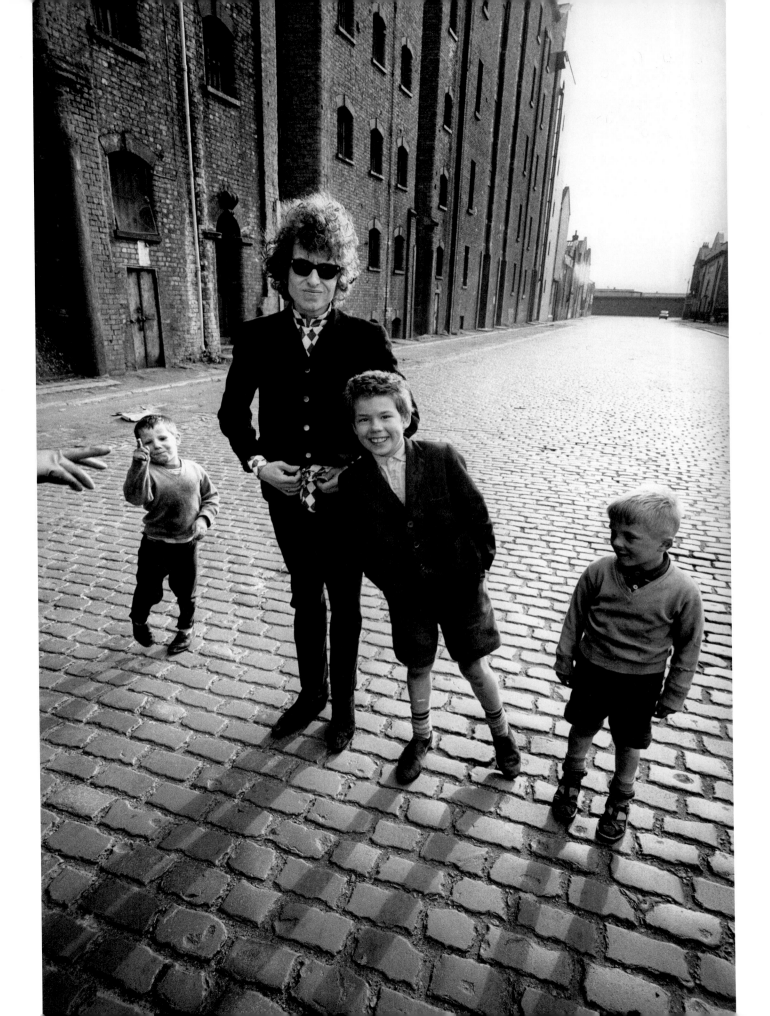

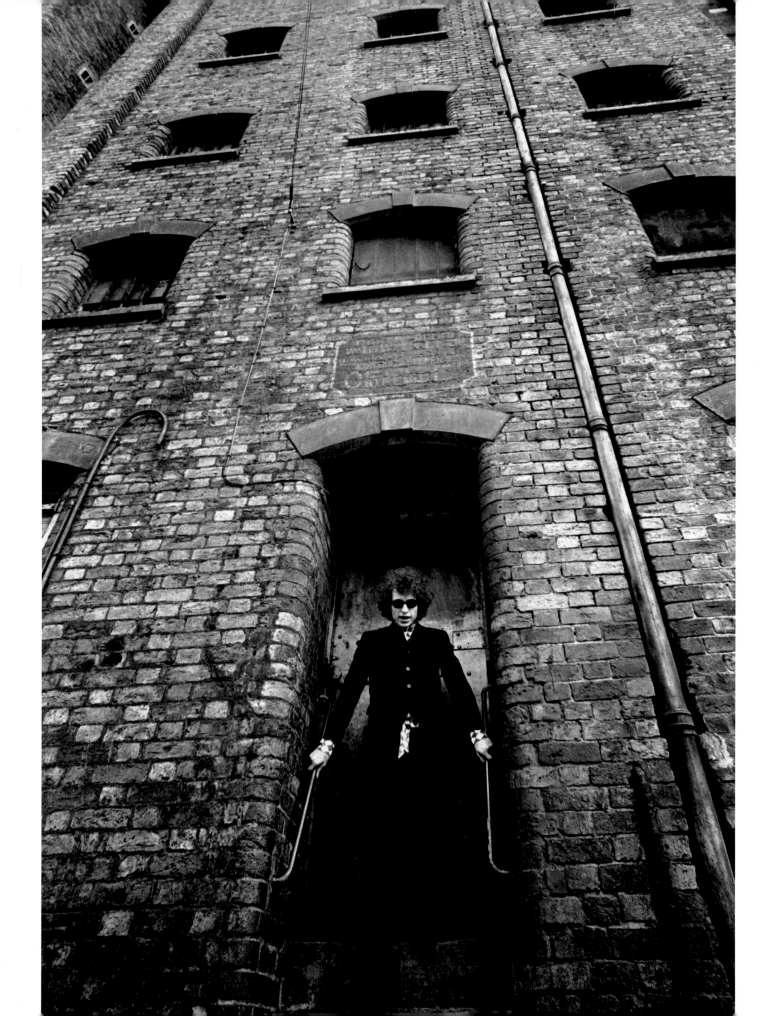

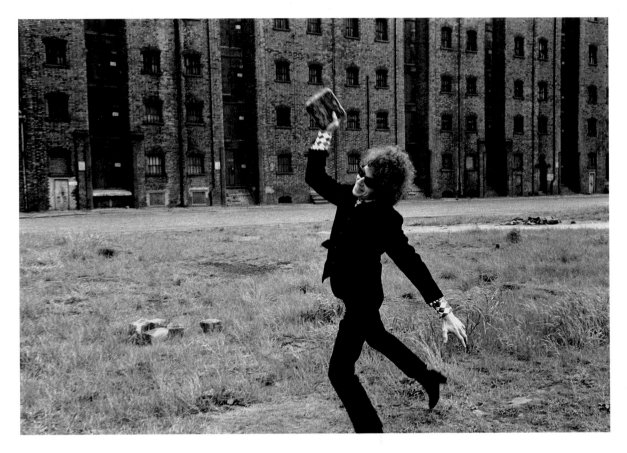

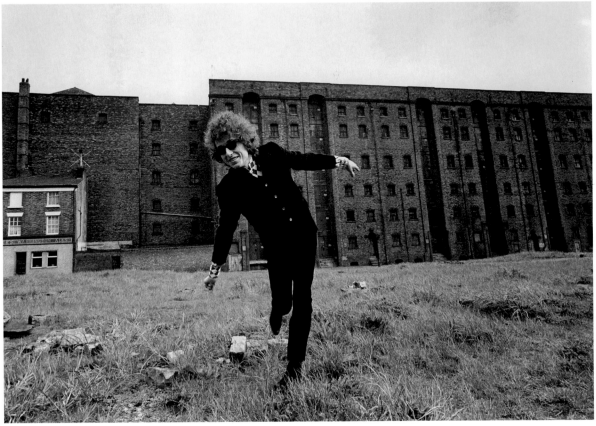

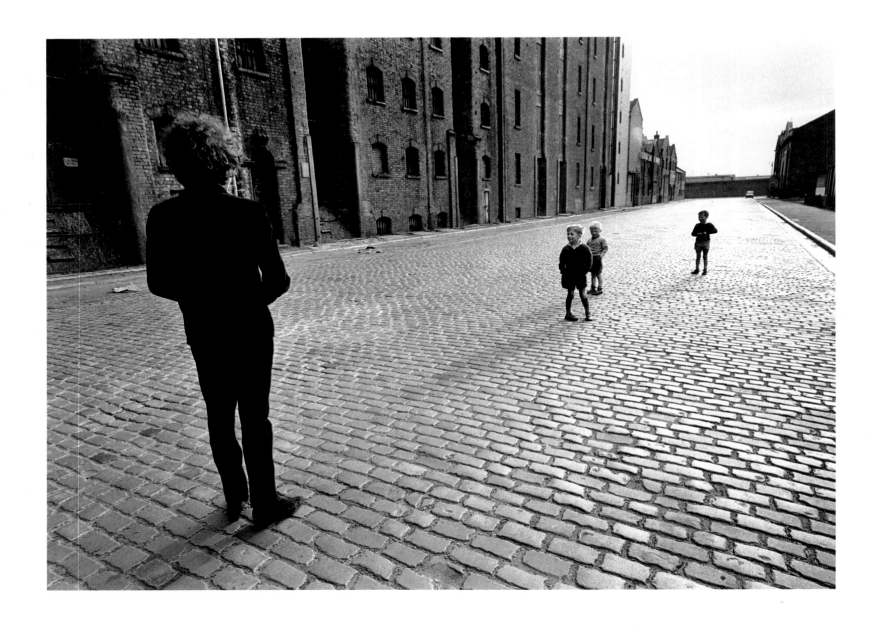

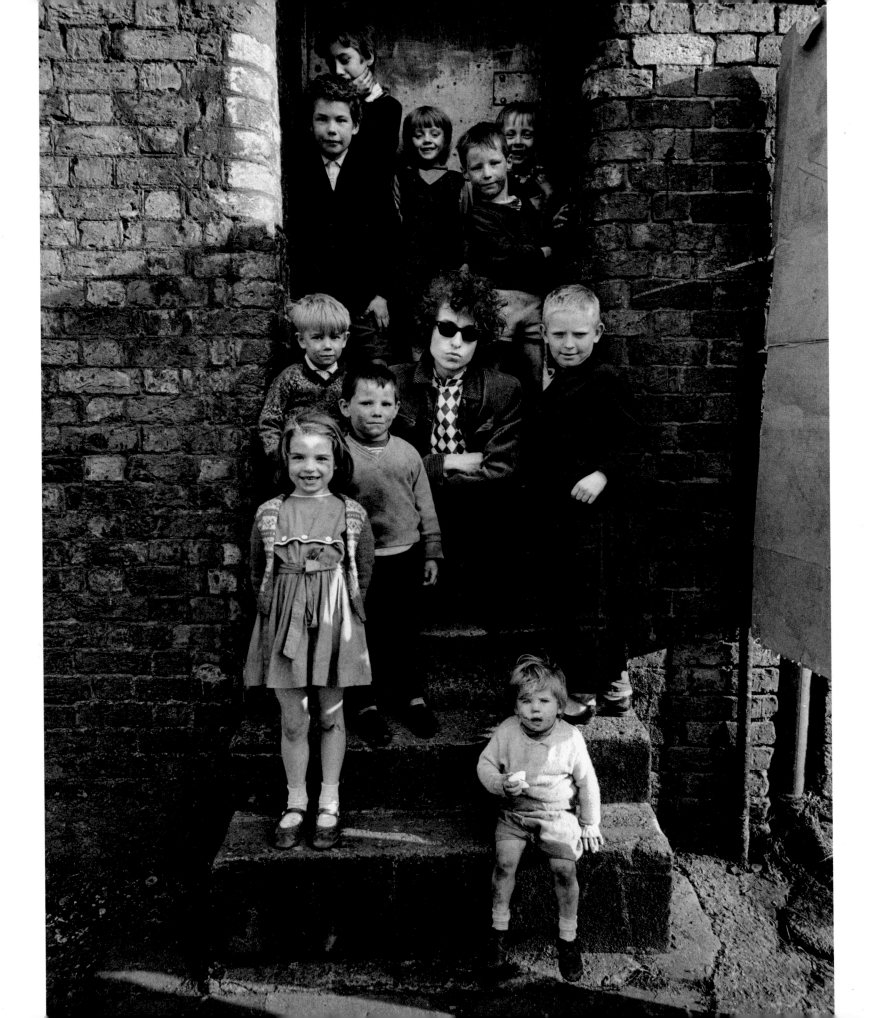

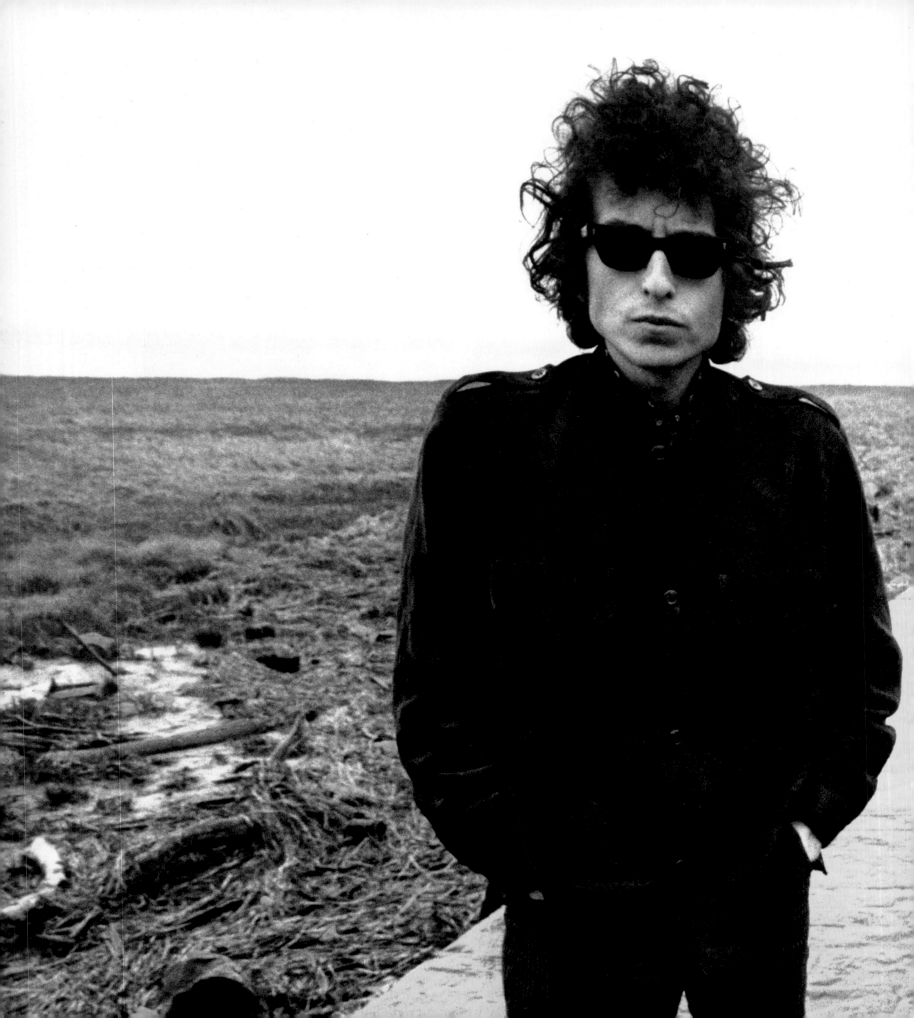

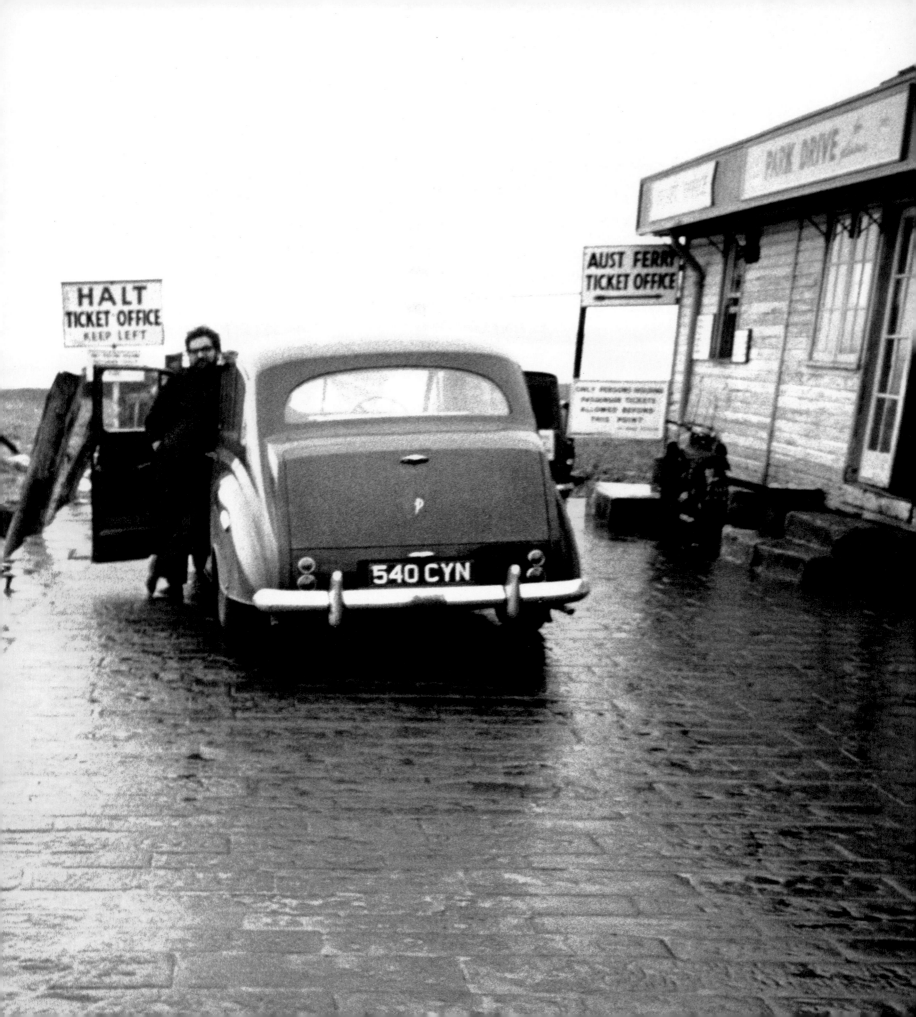

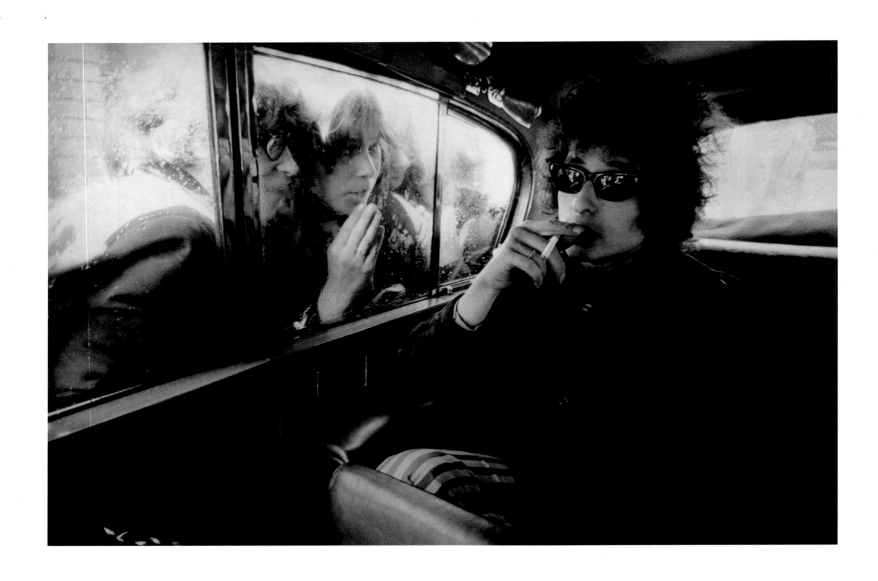

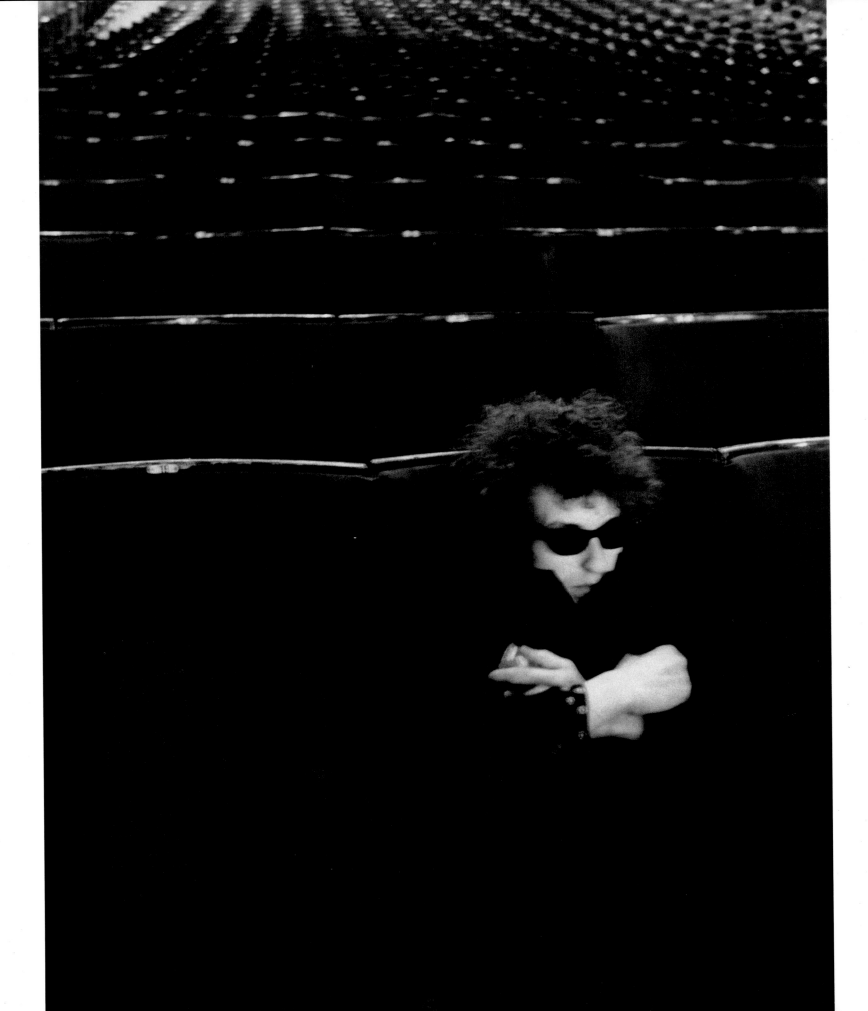

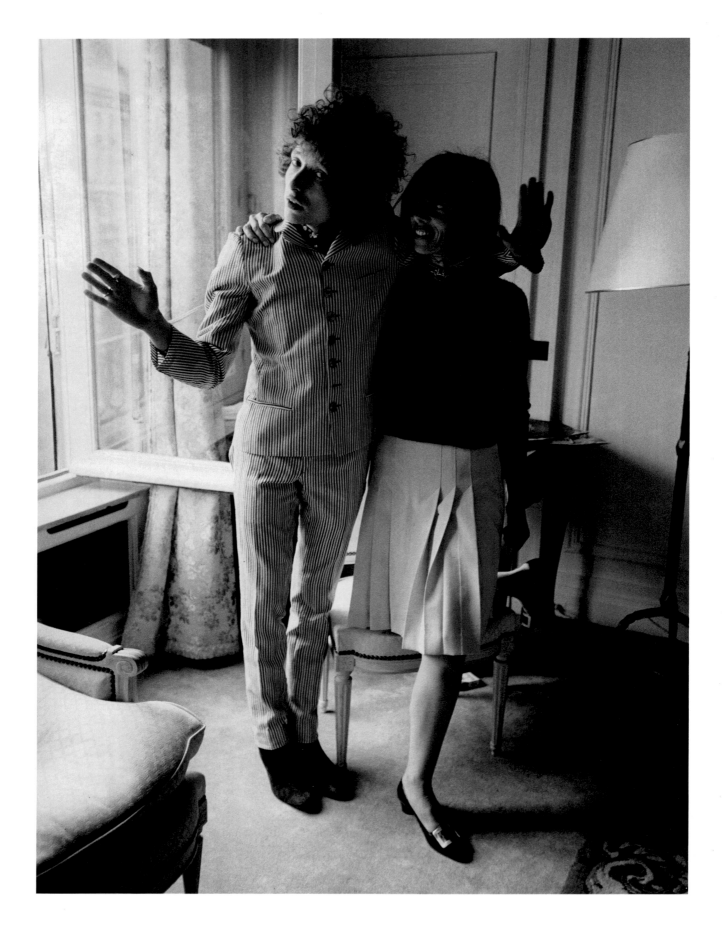

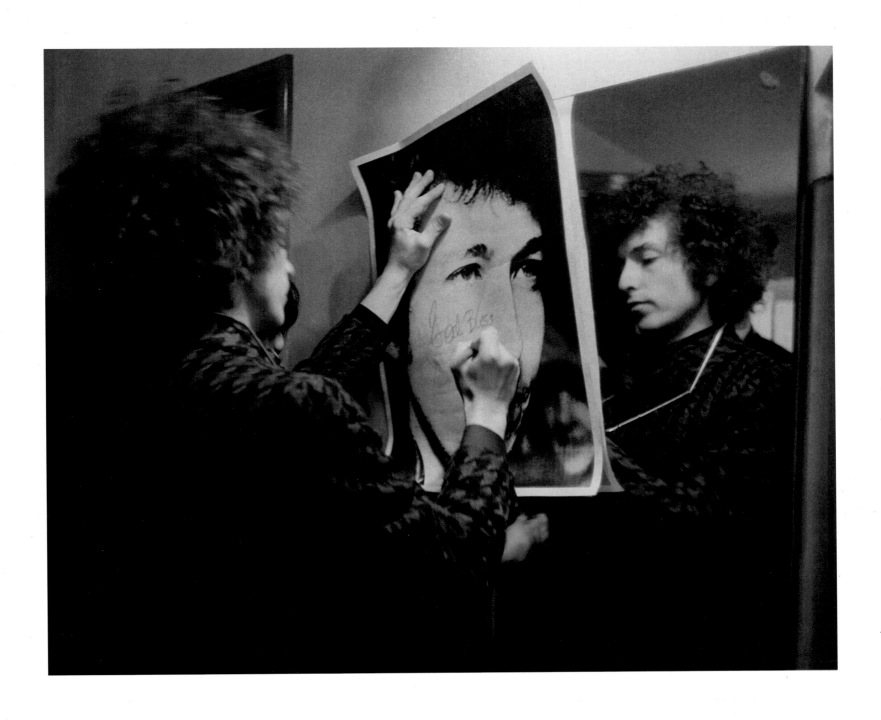

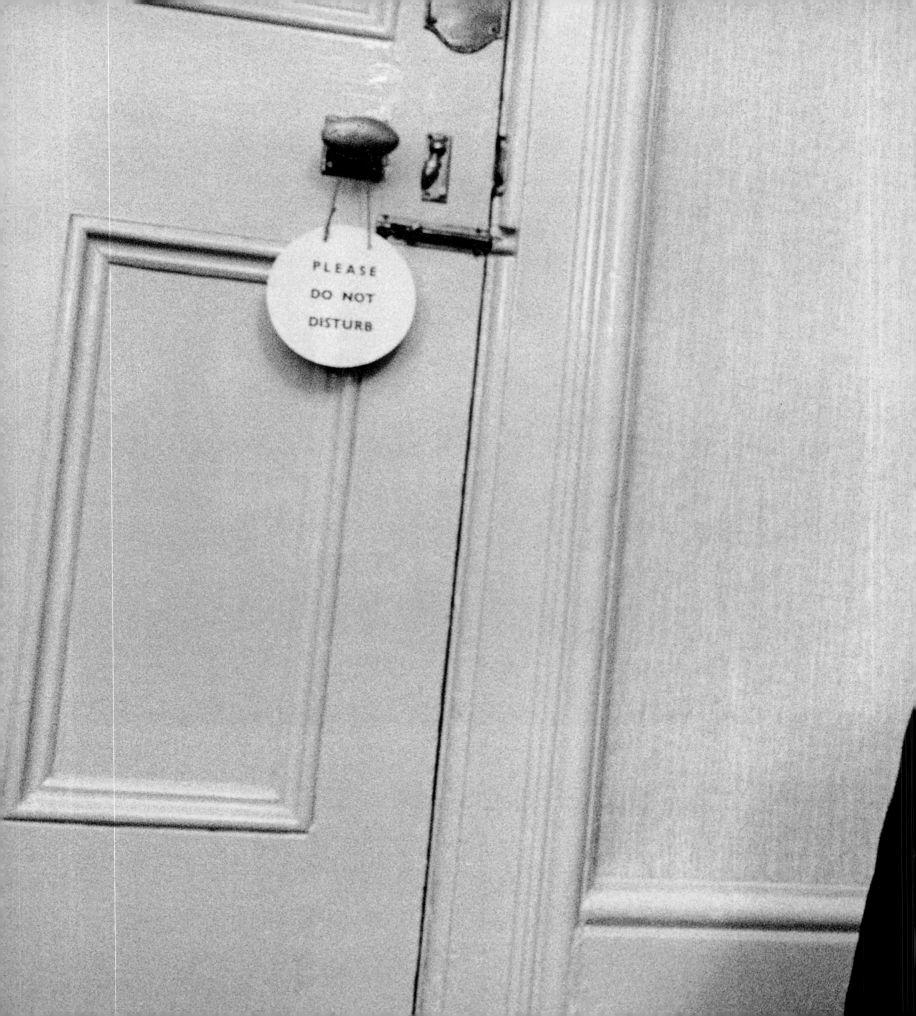

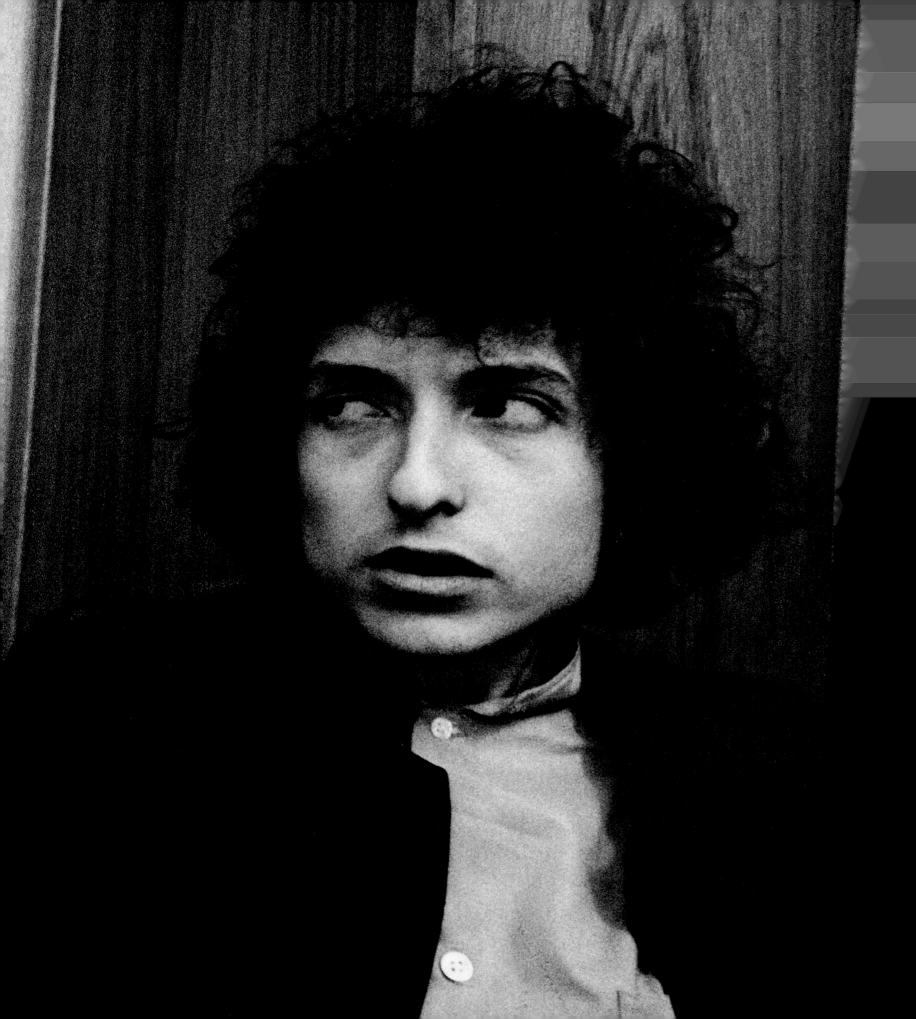

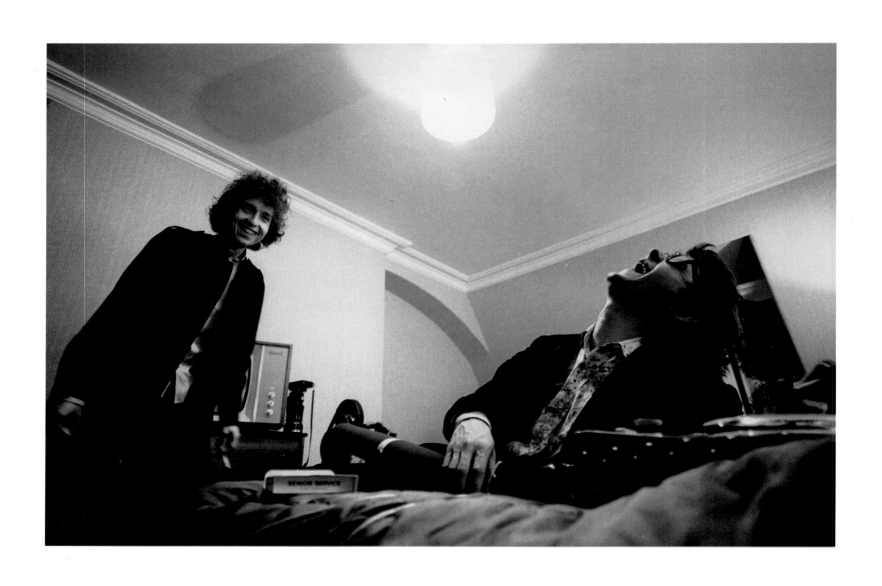

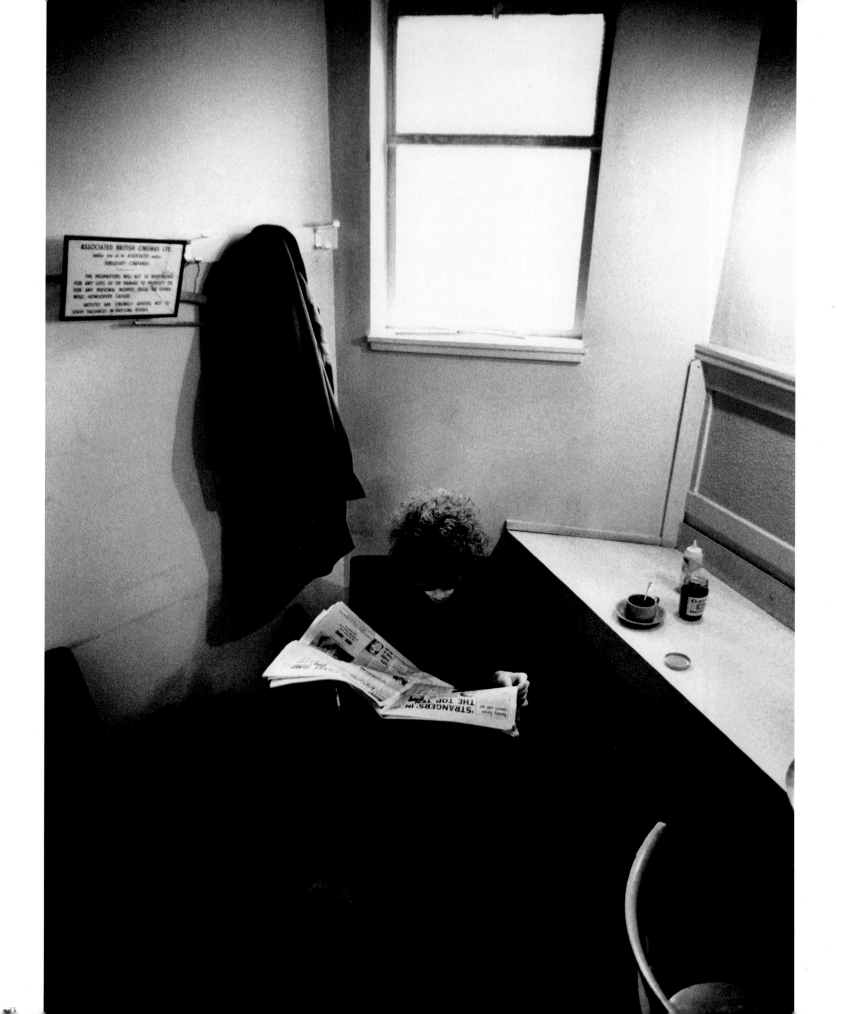

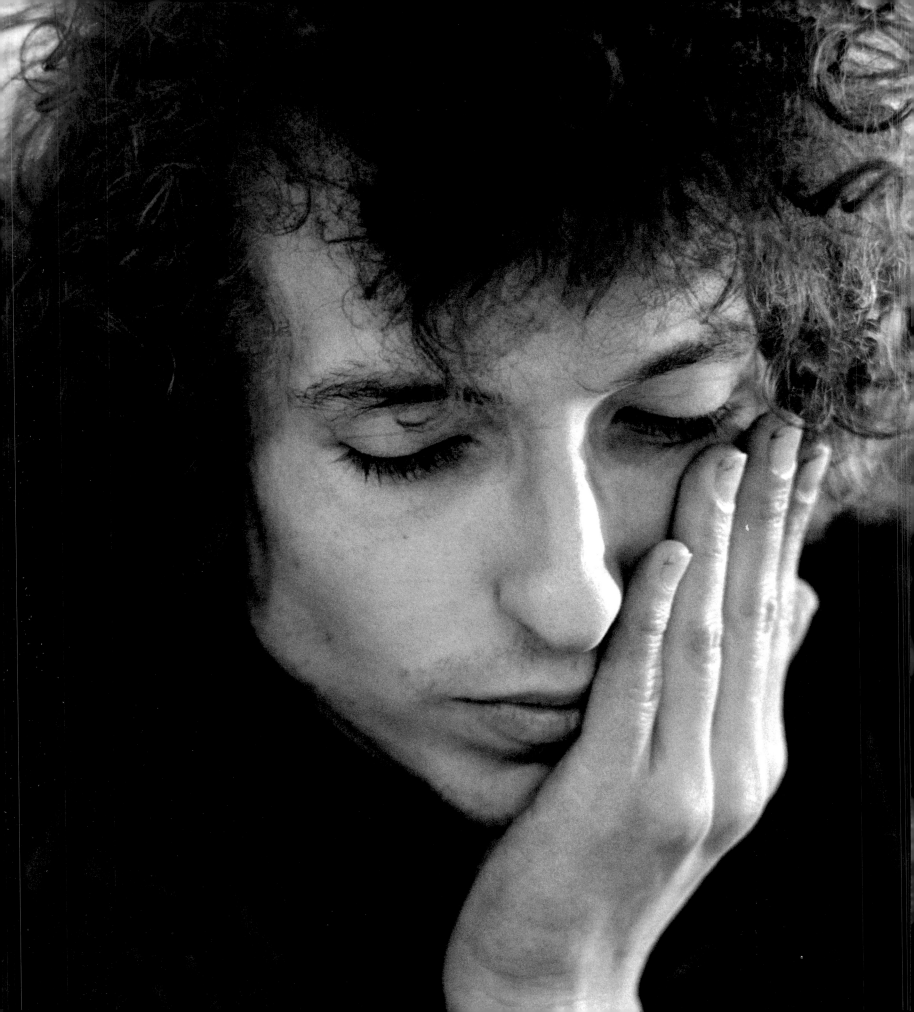

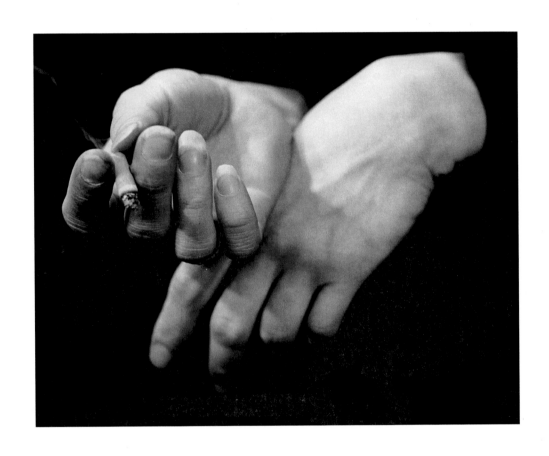

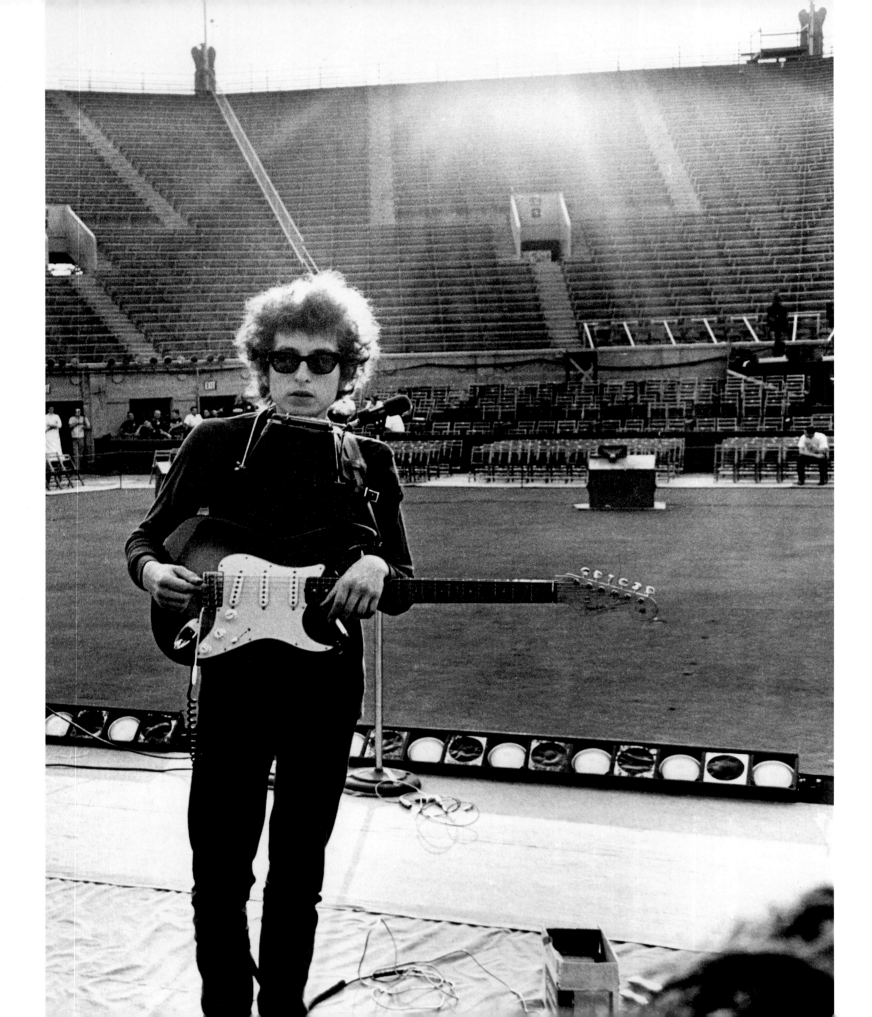

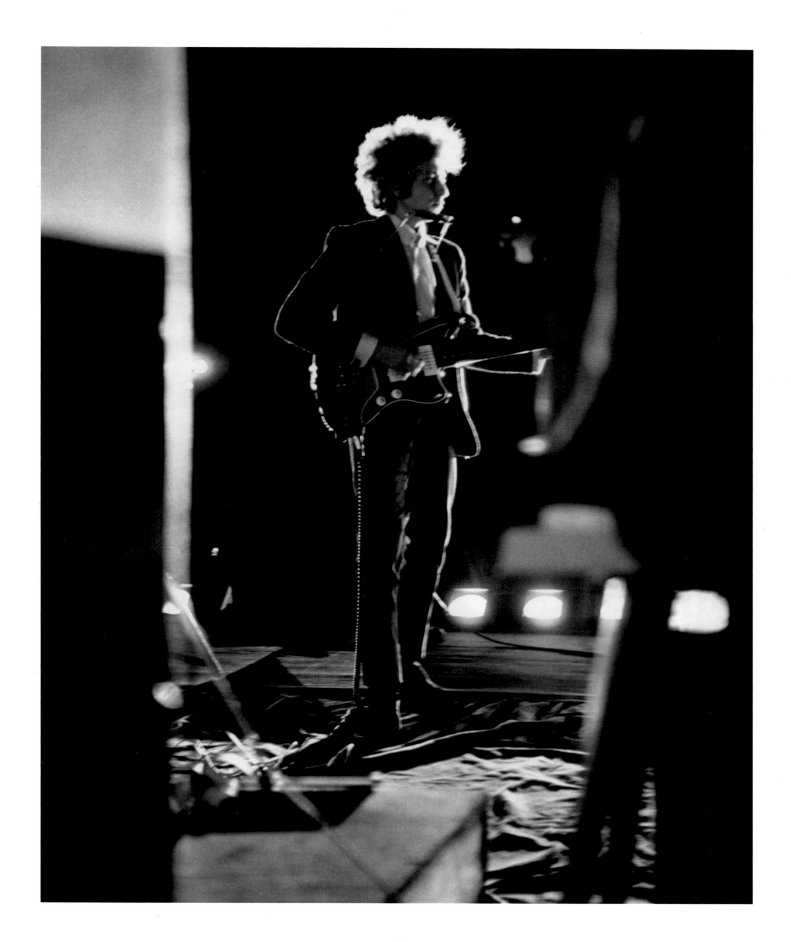

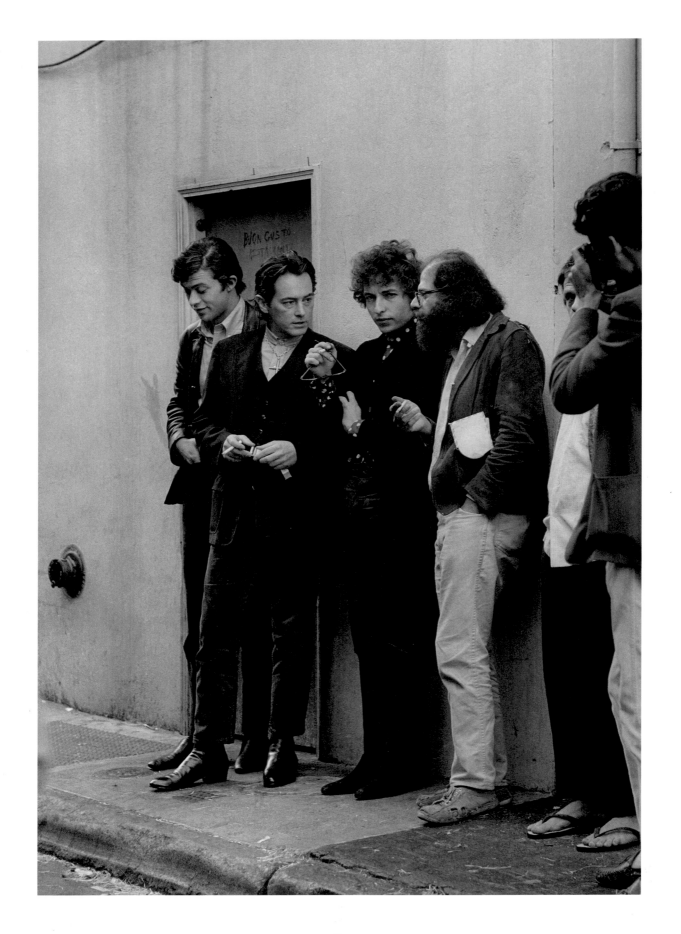

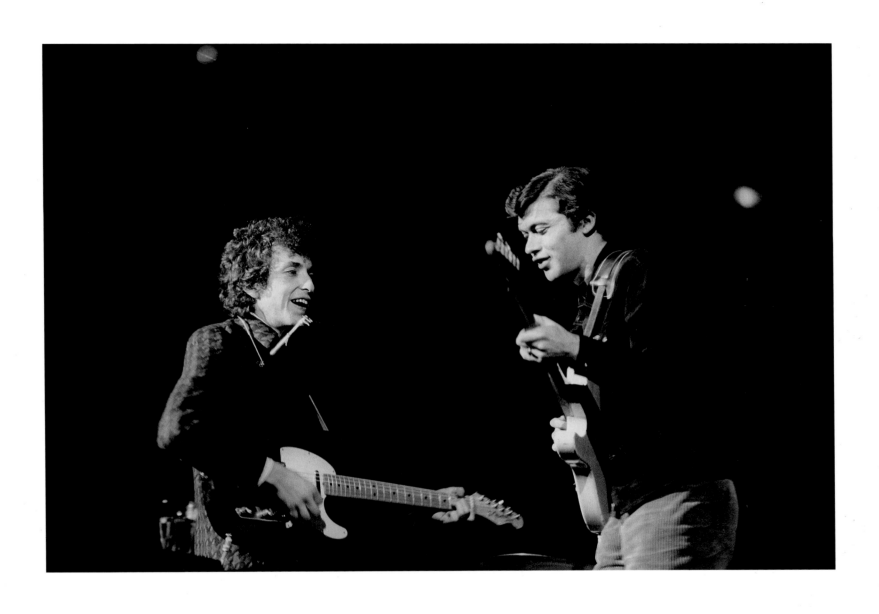

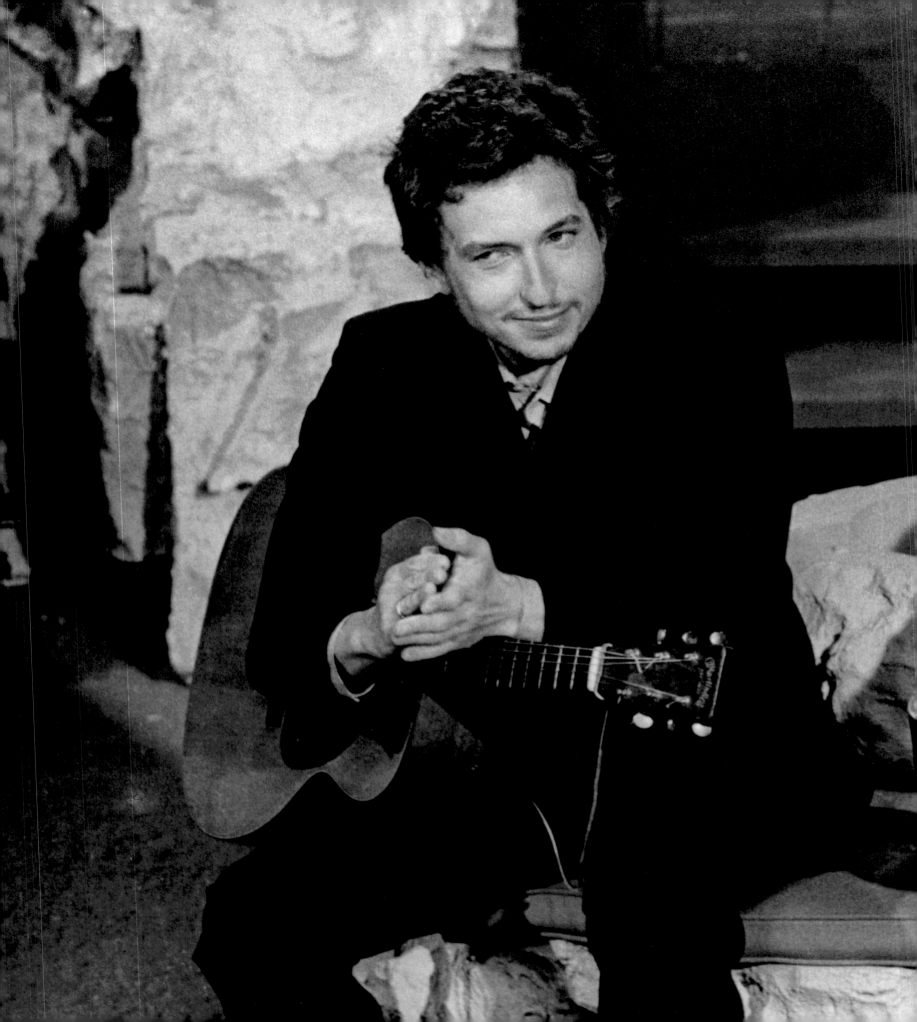

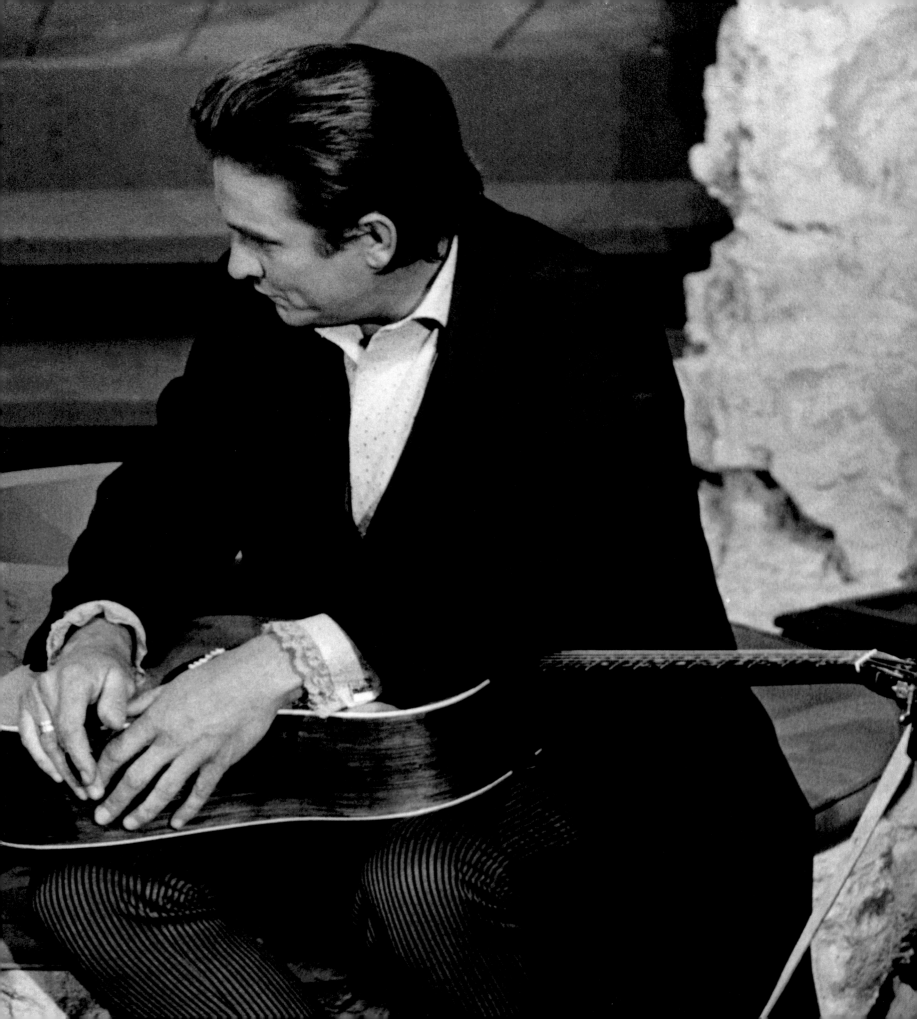

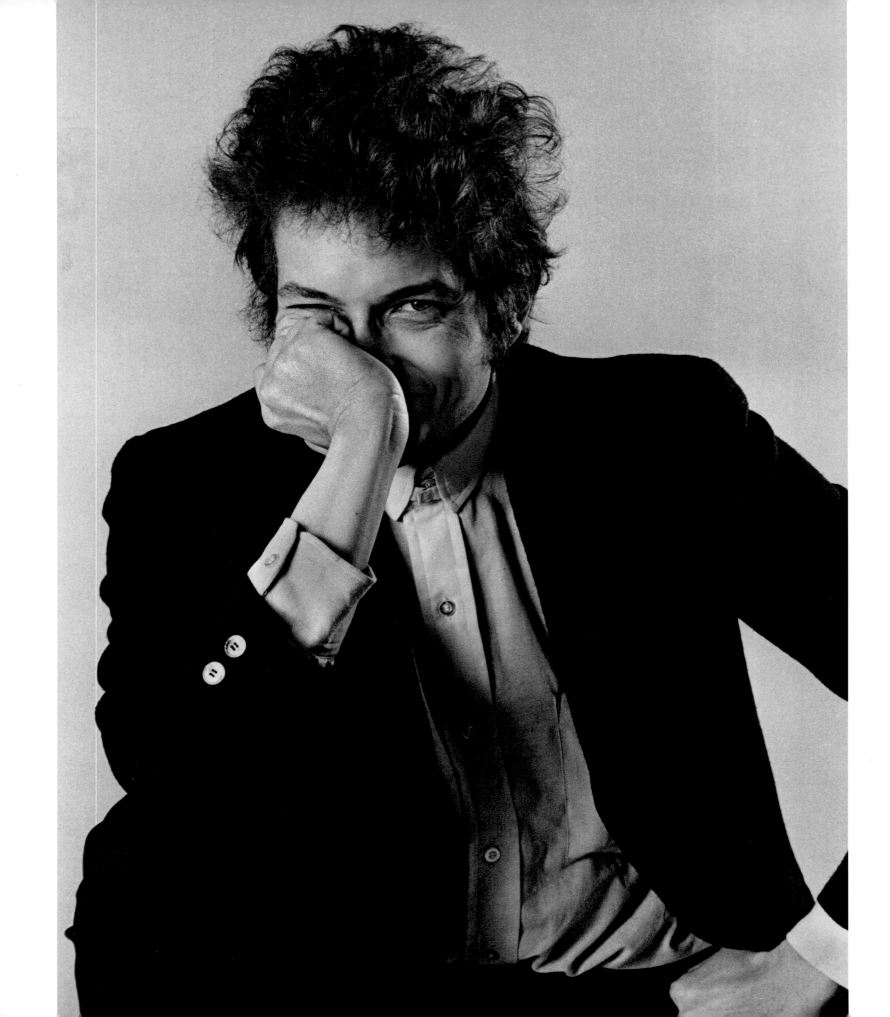

Biographies

BARRY FEINSTEIN has created many visual images of the entertainment industry that continue to be sought for commercial and artistic purposes. He began his career at Columbia Pictures. His work has appeared in *Life, Look, Time, Esquire, Newsweek,* and scores of European magazines. Feinstein was the exclusive photographer on Dylan's 1966 European tour and on the 1974 Dylan/The Band tour. He was also the still photographer for many major motion pictures, the director of *You Are What You Eat,* and a cameraman for *Easy Rider* and *Monterey Pop.* He has designed and done art direction for a myriad of album/CD covers and books, and has received more than thirty U.S. and international art-director and photojournalism awards.

DANIEL KRAMER is a New York–based award-winning photographer and film director. His portraits and picture stories have been widely published in national and international magazines and he was recently nominated by the Music Journalism Awards for his photographs of Bob Dylan. He also photographs for corporations and advertising agencies, and his work has been exhibited or collected by such museums as the George Eastman House, the National Portrait Gallery, the Whitney Museum of American Art, and the International Center of Photography, where he has conducted portrait workshops. Kramer's photographs of Bob Dylan have been published throughout the world and have appeared on the album/CD covers for Dylan's *Highway 61 Revisited, Biograph, The Bob Dylan Song Book,* and *Bringing It All Back Home* (which won a Grammy nomination and was selected by *Rolling Stone* as one of the "100 Greatest Album Covers of All Time"). Kramer's book, *Bob Dylan: A Portrait of the Artist's Early Years,* published in 1967, was the first major work on the artist.

JIM MARSHALL has worked most of his career in the music business doing magazine and editorial work, publicity, documentary photography, and album/CD covers. He was one of the chief photographers at the Monterey Pop Festival and at the original Woodstock, the only photographer granted backstage access at the Beatles' last concert, and the only person ever to squeeze Janis Joplin and Grace Slick into a single frame. He has more than five hundred album/CD covers to his credit. His work has been published worldwide and is included in the permanent collection at the Smithsonian. He is the author of *Not Fade Away: The Rock & Roll Photography of Jim Marshall.*

Commentary

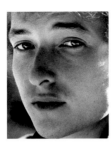

1964, page 11

For me, this picture is of the inner Dylan, the face of the young poet, and it is one of my favorites. It's in the permanent collection of the Whitney Museum of American Art in New York City.
Daniel Kramer

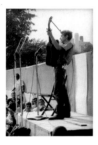

1963, page 12

Newport Folk Festival — Bobby at an afternoon session/workshop.
Jim Marshall

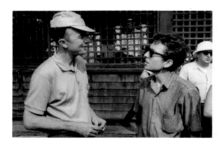

1963, page 13

This shot was taken with Pete Seeger backstage at the Newport Folk Festival on a Saturday afternoon. Bob sought counsel from Pete many times, for Pete Seeger was, and still is, the conscience of folk music.
Jim Marshall

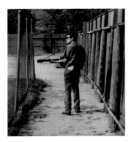

1963, page 14

Even then, at the Newport Folk Festival in 1963, he was a solitary man, following his own muses, walking around backstage, not being bothered by nothing. I think he was just beginning to become aware of the impact his music was having on a whole generation.
Jim Marshall

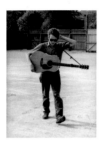

1963, page 15

Roaming backstage at Newport.
Jim Marshall

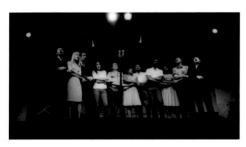

1963, pages 16–17

At the Newport Folk Festival — Peter Yarrow, Mary Travers, Paul Stookey, Joan Baez, Bobby, The Freedom Singers, Pete Seeger, and Theo Bikel singing "We Shall Overcome."
Jim Marshall

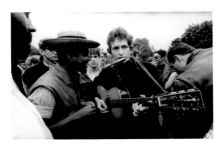

1964, page 18
A year later at the Newport Folk Festival with folk-singer Len Chandler. Bobby was probably the most important folkie around — it was amazing. Crowds followed him everywhere and a kind of wariness was just beginning to creep into his life and his relationship with the press.
Jim Marshall

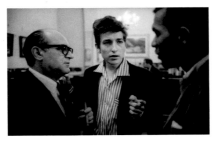

1963, page 19
After a concert in New York City, with Harold Leventhal (left), Woody Guthrie's manager.
Jim Marshall

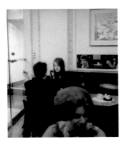

1963, page 20
Bob and his girlfriend, Suze Rotolo, in the café at Carnegie Hall.
Jim Marshall

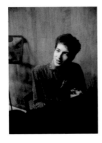

1963, page 21
I shot this at a Peter, Paul and Mary recording session in New York. They were recording "Blowin' in the Wind" and I think Bob played some chords on the piano. I believe this was the first major recording of a Bob Dylan song by an artist other than himself, and it went to the top of the charts.
Jim Marshall

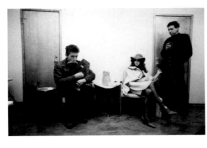

1964, page 22
The dressing room backstage at a Joan Baez concert — on the right is Joan's sister, Mimi Fariña, and her husband, Dick Fariña. Bob was playing his harpsichord and harmonica simultaneously.
Barry Feinstein

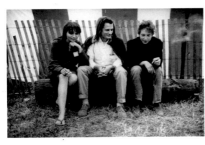

1964, page 22
Bob with folk musician Mike Seeger (Pete's brother) and Mike's wife, Marjorie, at the Newport Folk Festival.
Jim Marshall

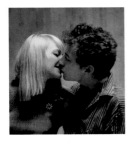

1963, page 23
Bob and Mary Travers at a Peter, Paul and Mary recording session. It was so different back then because artists just came and went to each other's gigs and sessions. Here, they were just sharing a kiss.
Jim Marshall

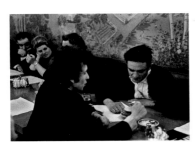

1965, page 24
I photographed Dylan at a concert in New Brunswick, New Jersey, in February. I didn't know Johnny Cash was coming to hear Bob until he arrived backstage. After the concert, I got some shots of them backstage and later we all went to a Chinese restaurant. Bob returned to New York in Cash's limousine so he could hear Johnny's latest album.
Daniel Kramer

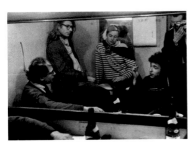

1964, page 25
I always found it both interesting and disturbing that performers who are accorded wonderful stage settings and special public arrangements are often asked to make do with sparse conditions backstage. In this tiny dressing room, two of America's great poets — Allen Ginsberg and Bob Dylan — whiled away the time before a concert at Princeton University. In the mirror can also be seen Peter Orlofsky, Barbara Rubin (a film producer), and yours truly behind the lens.
Daniel Kramer

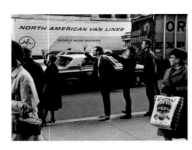

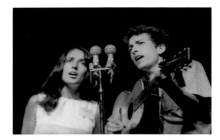

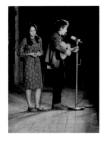

1965, pages 26–27
Bob, Peter Yarrow (left), and John Hammond, Jr. (right), appeared at my studio door one day wanting to make "street pictures." So we did, and a number of them ended up on the back cover of *Bringing It All Back Home*. I guess Bob always has a plan.
Daniel Kramer

1963, page 30
Bob and Joan Baez — I can still hear the songs but I cannot remember which one they were singing when this shot was taken at the Newport Folk Festival.
Jim Marshall

1964, page 32
Bob and Joan at some concert venue on the East Coast — she brought him out onstage and he sang. At the time Joan was a bigger star than Bob, but she had a great deal of respect for him. She really loved his music.
Barry Feinstein

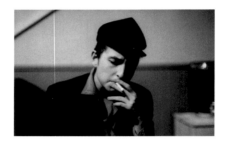

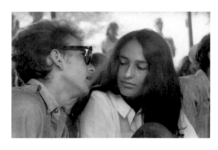

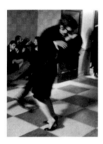

1963, page 28
Backstage at the Town Hall concert in New York City put on by Harold Leventhal. I think he was nervous when I took this shot.
Jim Marshall

1963, page 31
Is Bobby whispering sweet nothings in Joan's ear?
Jim Marshall

1964, page 33
I think Bob's concert at Lincoln Center in October 1964 put a lot of pressure on everyone involved. It was, in effect, the "next step up" and Bob was becoming a star. Afterward, there was a party and an opportunity for release; Joan, in her exuberance, hugged and then lifted the surprised Bob Dylan off his feet.
Daniel Kramer

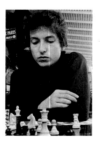

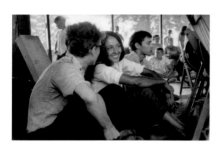

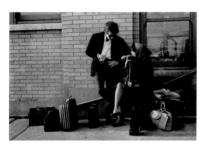

1964, page 29
Some of my best memories of Woodstock are of Bernard Paturel's Café Espresso where Bob spent a lot of time. I remember great food and wine, conversation, playing chess, and making music. I played "spoons."
Daniel Kramer

1963, page 31
Bob and Joan at the side of the stage at the Newport Folk Festival. They were the king and queen of folk music and for a while they had a magical chemistry.
Jim Marshall

1964, page 34
Bob and Joan were waiting to be picked up for a Buffalo concert appearance, having performed at Lincoln Center the night before. During the concert, back in the dark of the auditorium, a cop on security duty whispered to me, "He sings about some kind of philosophy, doesn't he?"
Daniel Kramer

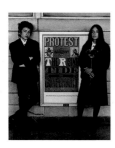

1964, page 35

Since the inception of the medium, photographers have been unable to resist using signs to underscore or add counterpoint to their pictures, and I'm no exception. And sometimes we really get lucky.
Daniel Kramer

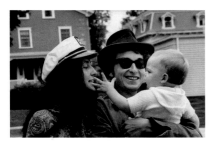

1964, page 36

Joan and Bob with the baby of Albert Grossman's business partner, John Court, at the Newport Folk Festival. I remember starting a rumor by telling the television media it was their child.
Jim Marshall

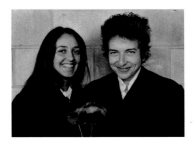

1964, page 37

We had just landed at Newark Airport after two nights of concerts, everyone feeling good. Bob bought Joan the flowers. I think this was a special moment in their relationship.
Daniel Kramer

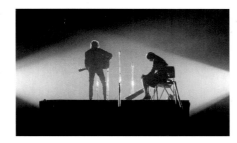

1965, pages 38–39

At a concert in New Haven, I stood behind the stage with the singer/writer, Dick Fariña, who had come to the concert with his wife, Mimi, Joan Baez's sister. We could hardly believe this wonderful sight. My fear was that something would change before I had a chance to photograph. I made a number of shots — but this is the one that really works. I call it "Crossed Lights." It's in the permanent collection of the George Eastman House in Rochester, New York.
Daniel Kramer

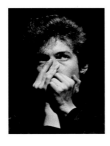

1964, page 40

Being a half-baked harmonica player, I was knocked out by Bob's great harp playing. He gave me a few pointers, but I don't think it is as easy as it sounds.
Daniel Kramer

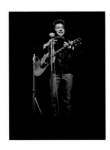

1964, page 41

Bob performing at Lincoln Center. I think this is the first time Bob's New York concert audience heard "Mr. Tambourine Man." When I arrived, the house management relegated me to a fixed press box above the balcony. When Bob heard this, he held up the start of the show until I was given free rein to shoot wherever I wanted. Wow.
Daniel Kramer

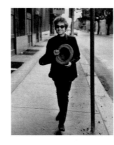

1964, page 42

The first Dylan concert I photographed was in Philadelphia. Someone had given Bob a top hat and he wore it throughout the trip. I thought it was perfect on him. I like this shot because it's of a very real Bob Dylan but one you don't get to see too often. I gave Bob a copy of this print.
Daniel Kramer

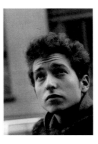

1963, page 43

This was taken the same day as the (now famous) tire shot.
Jim Marshall

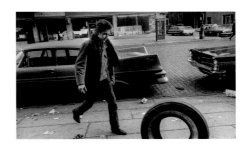

1963, pages 44–45

I am sick of talking about this goddamn picture, the bloody tire photo. But I should not bitch too much, because it's been a good shot for me and is probably one of the most famous I have taken. I think the pressure of being Bob Dylan had not totally sunk in for Bobby yet; his defense mode was just starting to come into play. It was taken one Sunday morning when Bobby, his girlfriend, Suze Rotolo, Dave Van Ronk, and Terri Van Ronk all were going to breakfast in New York. Just two frames were shot — no big deal — but I feel it shows Bob was still a kid in 1963. Contrary to popular belief, this shot did not inspire the song "Like a Rolling Stone."
Jim Marshall

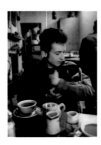

1963, page 46
Taken the same day as the tire shot. We were all having breakfast in a New York City coffeehouse where Bob made friends with the house kitten.
Jim Marshall

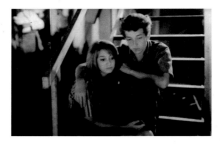

1963, page 47
At the Newport Folk Festival with Suze Rotolo. It's amazing how young and innocent they were.
Jim Marshall

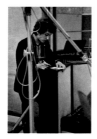

1965, page 48
During the recording session at Columbia Records for "Positively 4th Street" I had the rare opportunity to photograph Bob writing — making notes during the session, perhaps some last-minute changes to lyrics for a song about to be recorded.
Daniel Kramer

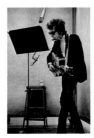

1965, page 48
The historic Columbia Records sessions for *Bringing It All Back Home* were extraordinary. Everyone there knew something was happening. Bob brought in background musicians and changed forever the way he would sound and where he would take his music. It was exhilarating. I like this picture; the way Bob's legs are crossed.
Daniel Kramer

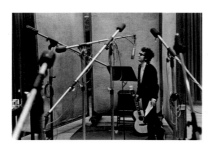

1965, page 49
Tom Wilson, Dylan's record producer, had an easy-going way of working with performers but knew how to get the job done. One day in the studio, Wilson noticed that Bob had a habit of wandering away from his microphone position that adversely affected the quality of the sound. On this day, the mikes and booms were surreptitiously arranged to keep Bob on his spot, and at some point during the session, Bob realized this and called out in mock anger to be released from his confinement.
Daniel Kramer

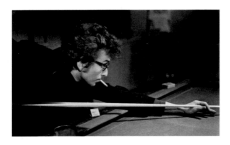

1965, pages 50–51
In January 1965, I went to Woodstock to photograph Dylan for the *Bringing It All Back Home* album cover. On one of those evenings, Bob, his road manager Victor Maimudes, their friend Bernard Paturel, and I went to Kingston to play pool and hang out. I don't remember who won, but we had a good time.
Daniel Kramer

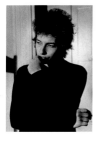

1965, page 51
At the pool hall in Kingston, New York, Bob and I had fun taking turns at the pinball machine (he tilted a lot).
Daniel Kramer

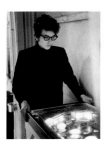

1965, page 52
I didn't ask for this one — Bob deep in thought, a private moment.
Daniel Kramer

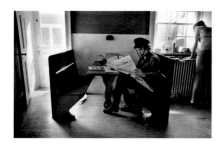

1964, page 53
This picture was made on August 27, 1964, during my first photo session with Dylan. We were at the Woodstock, New York, home of his manager, Albert Grossman. Albert's wife, Sally Grossman, had just come in from the pool. I felt that Bob wanted to delay the session, but he knew I was already shooting. After this, we made some portraits on the porch and things loosened up.
Daniel Kramer

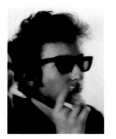

1964, page 54
The quintessential Bob Dylan.
Daniel Kramer

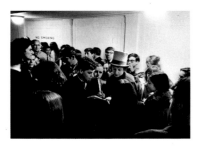

1964, page 55
After the concert in Philadelphia, Bob made himself available to his fans, signing autographs until everyone got one, and then chatted with some who had snuck backstage. Things were sure different then.
Daniel Kramer

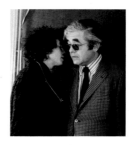

1966, page 56
This is a shot of Albert Grossman and Bob talking quietly. When Albert came into the business he secured the best financial deals for the musicians he represented. There was a palpable closeness between Albert and Bob, and they didn't put each other's business on the street. They always talked very confidentially, so nothing was wrongly overheard or misstated.
Barry Feinstein

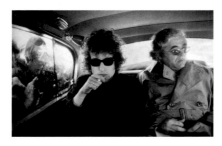

1966, page 57
While in London, both Bob and Albert were being really cool while these girls were trying to get Bob's attention at the window. This kind of fan-frenzy was probably tedious sometimes. Albert and Bob had a very interesting relationship, sort of father-to-son or professor-to-student. Albert talked to Bob about the things that mattered and was one of the people who helped to develop Bob.
Barry Feinstein

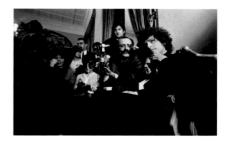

1966, page 58
This was taken at the George V Hotel in Paris at the final press conference of the 1966 European tour. Bob had bought the marionette at a flea market that morning and kept it perched on his knee throughout the entire press conference. Every time the interviewers asked Bob a question, he'd whisper and then listen to the doll, which he named Finian, and then give his answer. He had the French press going crazy. At one point someone asked what he was certain of, to which Bob replied, "The existence of ashes, doorknobs, and windowpanes." Later, he told me that the reason he didn't like giving interviews was because nobody ever asked the right kind of questions.
Barry Feinstein

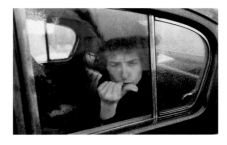

1966, page 59
In Bristol, England, on another rainy day.
Barry Feinstein

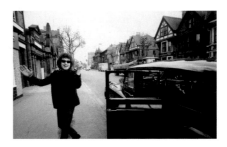

1966, page 60
When we drove into Sheffield, England, Bob jumped out of the car because of a sign he had seen. It was one of his happier moments, having fun along the way.
Barry Feinstein

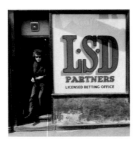

1966, page 61
Minutes later in Sheffield. He went into the place to check it out (he didn't place any bets). On his way out I took this picture.
Barry Feinstein

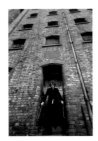

1966, page 64
This old factory in Liverpool was a great place to take photographs. I love the angles of this shot.
Barry Feinstein

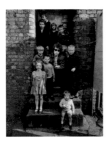

1966, page 67
Before we left Liverpool, I wanted to take one last shot of all of them together on the steps. It's one of my favorites of the day.
Barry Feinstein

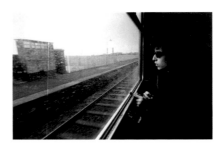

1966, page 62
On the train going from Dublin to Belfast in Northern Ireland. He was just sitting there looking out the window. There's something about Bob — he liked to touch windows though I'm not sure why. Maybe it was the rainfall, but it was a wonderful moment. It was the only time I've been on a train where you had to go through customs in one country.
Barry Feinstein

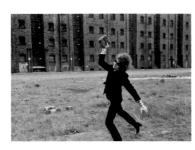

1966, page 65
And then Bob started doing his mock Olympic try-outs for the shot put…
Barry Feinstein

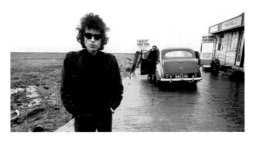

1966, pages 68–69
At the Aust Ferry in England just before taking the ferryboat across to Wales — leaning against the limousine was Howard Alk, one of the cameramen. It was wet and cold and very isolated.
Barry Feinstein

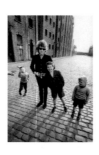

1966, page 63
During the tour, we went to Liverpool to shoot some pictures and after a while all these children came around. Bob asked to be photographed with them. They had no idea who he was. They were little waifs, running around, and Bob just fell in love with them. He really likes children and had a fun time talking to them.
Barry Feinstein

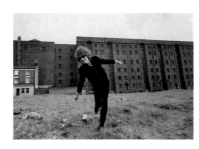

1966, page 65
…and then for curling.
Barry Feinstein

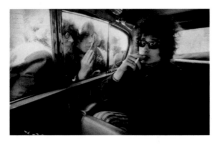

1966, page 70
Back in London — Bob just sat there looking straight ahead and didn't want to deal with anybody.
Barry Feinstein

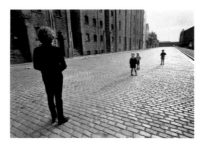

1966, page 66
Bob and the children.
Barry Feinstein

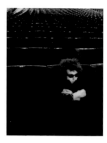

1966, page 71
At the Royal Albert Hall in London during a sound check, Bob just sat there, arms crossed, buried among all those seats, listening to the sound. At the same time, there were movie cameras being set up all around him for a documentary film.
Barry Feinstein

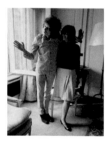

1966, page 72
At the George V Hotel in Paris — we were up in the suite and there were a bunch of girls on the street yelling for Bob, so we asked one of them to come upstairs and have her picture taken with him. It was one of those light, funny moments. He was very nice to her and she loved it. She didn't speak any English and was a typical young French lady. (I loved her pleated dress.) I'll bet she's never forgotten that moment.
Barry Feinstein

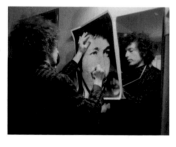

1966, page 73
Taken at the Olympia Concert Hall in Paris in one of the rare moments that I ever saw Bob Dylan autograph anything.
Barry Feinstein

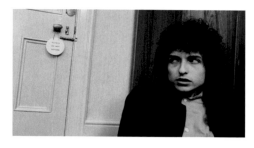

1966, pages 74–75
I call this picture "Knock, Knock, Knockin' on Heaven's Door." Someone had just knocked at the door while we were all sitting around the hotel room in Birmingham, England. It had the same feeling as the beginning of an Alfred Hitchcock film — the height of paranoia.
Barry Feinstein

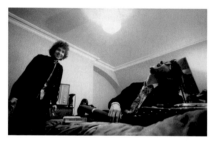

1966, page 76
I call this "The Two Bobs" — Dylan and Neuwirth, scheming and laughing in Birmingham. Bob had just said something that made Neuwirth howl.
Barry Feinstein

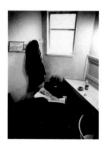

1966, page 77
At the theater in Birmingham — Bob liked to have his tea and sit by himself and read. I just love this image. He created his own environment.
Barry Feinstein

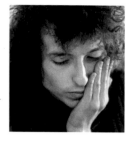

1966, page 78
I took this in Dublin, Ireland, when I hooked up with the tour. I don't know what to say…he looked so peaceful, as if he was contemplating something that the rest of us don't think about very often. He looks so calm, like he's dreaming.
Barry Feinstein

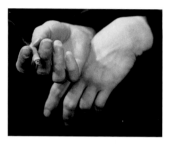

1966, page 79
These hands made some great music. Bob used his hands a lot when he was speaking.
Barry Feinstein

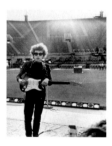

1965, page 80
August 28, 1965, was an unforgettable day — it was the day the music stopped, or started, depending on your view. I always felt this picture, made during the sound check before the concert at Forest Hills, summed up the moment: the empty stadium and the unknown. In the next few hours the crowd and the night would arrive — with Dylan willing to face whatever, with the electric guitar now audaciously a part of him.
Daniel Kramer

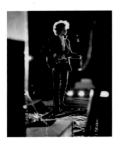

1965, page 81
Later that night at Forest Hills Stadium — Bob's first performance after going electric at the Newport Folk Festival. He was the gladiator about to do battle with a passionate and demanding crowd. The times they were a-changin'.
Daniel Kramer

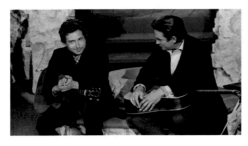

1969, pages 84–85
This was taken during a Johnny Cash television show taped in Nashville. Bobby was always comfortable around Johnny, and they had a mutual love and respect for one another.
Jim Marshall

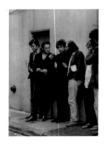

1965, page 82
Robbie Robertson, Michael McClure, Bobby, and Allen Ginsberg in a San Francisco alley now named Kerouac Strasse.
Jim Marshall

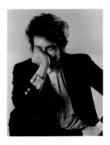

1965, page 86
I learned early on that Bob Dylan doesn't like to pose for pictures in the studio. It was only after much urging that he finally agreed to this session. I think it was worth it for both of us. Later, Bob selected this picture for his tours and then for the promotion of the film *Don't Look Back*. It was also the jacket image of my first book about Dylan and then became a poster and postcard. I think it's become one of the best-known images of Bob Dylan around, but getting it was not easy.
Daniel Kramer

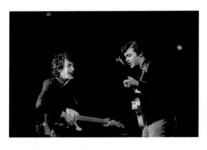

1965, page 83
Bob's first electric tour: this was taken at San Francisco's Masonic Auditorium — Bob playing guitar with Robbie Robertson. During the concert it seemed as if Bob was having a lot of fun and that maybe the freedom of rock and roll had opened him up from the constraints of folk music.
Jim Marshall